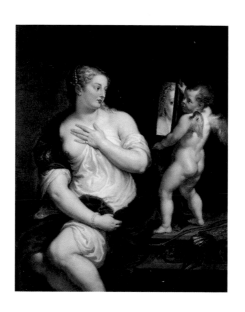

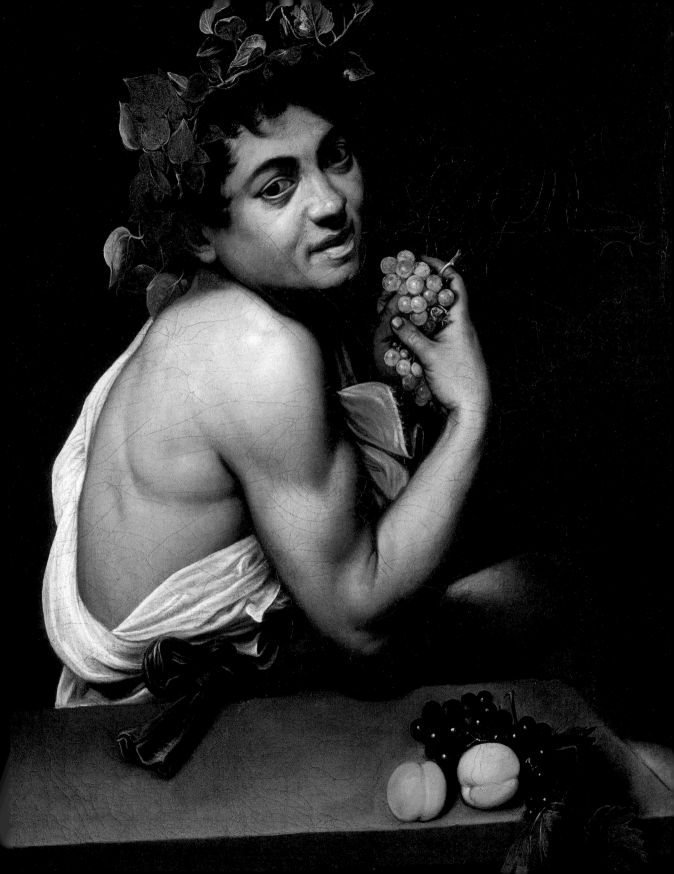

Baroque

HERMANN BAUER/ANDREAS PRATER
INGO F. WALTHER (ED.)

TASCHEN

HONGKONG KÖLN LONDON LOS ANGELES MADRID PARIS TOKYO

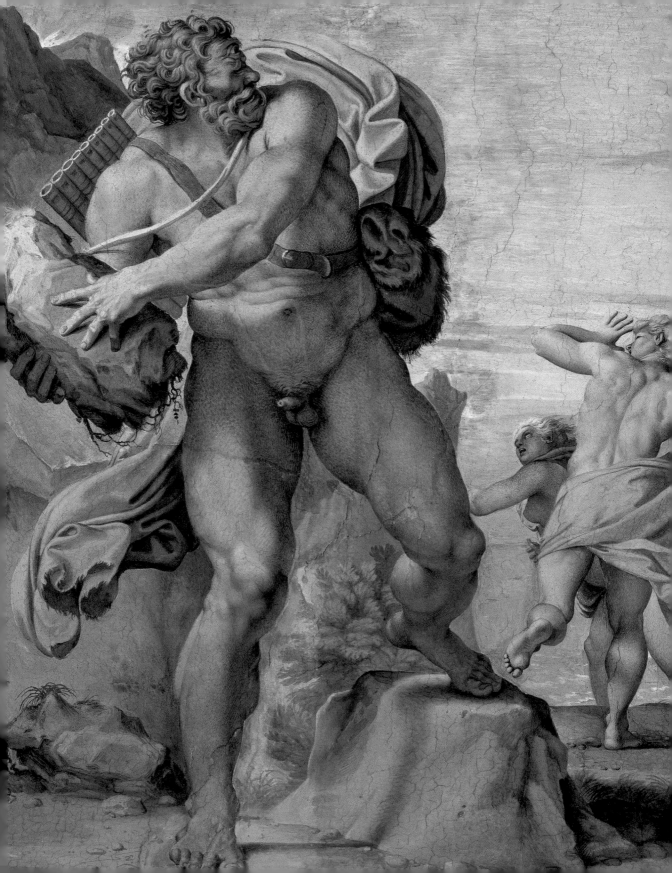

contents

The painting of the 17th century in Italy, France, Germany, Spain and the Netherlands

The naming of an era

The age of the Baroque, between absolutism and the Enlightenment, is acknowledged as the last all-European style. Long regarded as merely an eccentric offshoot of the Renaissance, Baroque presents a complex and dynamic variety of form and expression in stark contrast to the controlled moderation of Neoclassicism. Worldly joys and sensuality, religious spirituality and stringent asceticism, wide formal diversity and strict regulation all went hand in hand. At the same time, theatricality and stagelike settings entered the world of art with the advent of illusionism. Pageantry, pomp and courtly ceremony were not simply an expression of Baroque exuberance, but also an artistic device in the portrayal of crowd scenes. In Rome, Caravaggio succeeded in achieving a decisive breakthrough with his dramatic use of chiaroscuro, while in Bologna it was the Carracci who established the Baroque style of painting. French art was dominated by the heroic landscapes of Poussin, the night pieces of La Tour, and Claude Lorrain's lyrical handling of light. In Spain, we find the warm colority of Murillo, the contemplative piety of Ribera and Zurbarán and the forcefully expressive court portraits by Velázquez, while Germany's contribution to Baroque painting reached its zenith in the delicate landscapes of Adam Elsheimer.

No other period in the history of European art has proved so difficult to pin down in terms of academic and scholarly definition, in describing its characteristic phenomena, in specifying its time span and in exploring its spiritual and intellectual background. Ever since scholars turned their attention to the Baroque age a century ago, their research has been marked by contradiction and controversy to an extent paralleled only by Mannerism, itself a term coined at a fairly late stage in academic research in order to classify the transition between Renaissance and Baroque.

At the time, such questions of period and epoch were unknown, and the term "baroque" as we know it was unheard of. Neither the patrons nor the painters themselves, nor the theoreticians of art, of whom there were many, actually used this term to describe artistic procedures and achievements. Unlike Rococo, which adopted the expression *goût rococo* for itself, the style we wish to examine here was described, at most, by its contemporaries as *grand goût* in keeping with the absolutist world view of the 17th century and the patrons' desire for prestige and pomp. Only in the workshops and studios do we find the word "baroque" used to describe the curving lines of furniture and the dissolution of firm contours in painting. In the satirical and burlesque literature of Italy, we find the word "barocco" in use from around 1570 to describe an odd or witty idea.

It was the rationalist art critics of the mid-18th century who began employing the term to describe a style they saw as a florid, bizarre and thoroughly tasteless travesty of all the rules of art. Adherents of the new classicist doctrine were well aware of the key role played by certain masters of the previous era, amongst them Gianlorenzo Bernini (1598–1680), whom they held responsible for nothing less than a general decline in artistic standards – an evil whose roots they traced back to Michelangelo. By around the end of the 18th century and the beginning of the 19th, the term had already entered common usage in a thoroughly pejorative sense and, with that, its transformation from polemical insult to accepted stylistic epithet was virtually inevitable, following the same time-honoured pattern by which Gothic, to name but one other similar example, also became an accepted and neutral term. In fact, it was the avantgarde artists of the

1590 — Dome of St Peter's in Rome built by Giacomo della Porta to plans by Michelangelo 1595 — Start of Dutch colonisation in the East Indies 1600 — The philosopher Giordano Bruno is condemned as a heretic and burnt at the stake

"I don't know if it was Lomazzo who wrote that drawing was the essence of painting and colour the form. To me it seems the other way round: namely that drawing determines the entity, and that nothing has shape outside its precise boundaries; I understand drawing as a simple delimitation and measure of quantity. At the end of the day, colour has no existence without drawing."

Domenichino to Francesco Angeloni

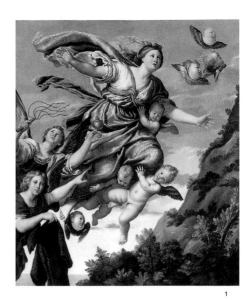

1. DOMENICHINO

<u>The Assumption of Mary Magdalen into Heaven</u>
c. 1617–1621, Oil on canvas, 129 x 100 cm
St Petersburg, Hermitage

1

19th century who eventually established a more positive attitude to what had hitherto been regarded as the "style of decadence". The works of Diego Velázquez (1599–1660), Rubens, Rembrandt (1606–1669) and Frans Hals (1591–1656) possessed specific painterly qualities in which the Impressionists, at any rate, took a keen interest.

The major monographic work on Diego Velázquez and his century published in Bonn in 1888 by the German art historian Carl Justi (1832–1912) applied a new approach to the era, seen through the eyes of a generation already influenced by the Impressionist sensitivity for light, colority and tone which had begun to permit a revaluation of the Baroque. The emergence of this more positive historical reception was to culminate in the work of the Swiss art historian Heinrich Wölfflin (1864–1945) and the Austrian art historian Alois Riegl (1858–1905), to name but two. Rome was designated the cradle and capital of Baroque and the stylistic characteristics of the period were distinguished systematically and normatively from those of the Renaissance.

Renaissance and Mannerism are widely regarded as the direct stylistic precursors of the Baroque. Indeed, there is much to be said for the art-historical view that the period from the Early Renaissance of the 15th century through to the Neoclassicism of the late 18th century constituted a single and continuous cultural development. In terms of content and theme, there are a number of constant factors which, for all their modal and aesthetic differences, certainly indicate an undeniable homogeneity. The principle of illusionism, for instance, creating a sense of spatial expansion in which monumental mural and ceiling painting transcends the bounds of real architecture into illusory celestial realms, is just one example of a leitmotif that first emerged in the Early Renaissance and was then taken to its full artistic and theoretical flowering in Baroque art. The theme of column orders, for example, dominated the formal architectural syntax of the day. Even such radical innovators as Michelangelo in the 16th century or Bernini and Francesco Borromini (1599–1667) in the 17th century merely elaborated on their stylistic potential without ever actually questioning the underlying principle. The same is true of the portrayal of ancient gods and heroes in paintings that were neither objects of some neo-heathen worship nor purely decorative designs, but mythologically charged bearers of meaning capable of elevating a contemporary event to a higher plane of historical and mythological reality.

Other variables in painting include the use of chiaroscuro and the triad of cardinal colours, the juxtaposition of the primaries – red, yellow and blue – which are blended to create all other colours. As a counterpoint to this colorism, we find the non-coloured chiaroscuro with its extremes of black and white which modifies the palette of the artist to provide countless possibilities. The awareness that chiaroscuro provides a means of portraying light and darkness as elementary factors in the overall structure and texture of the painting rather than as a means of depicting specific lighting conditions is still relatively new at this stage.

A further constant factor is the use of allegory and, with that, the humanistic love of coded statements which were regarded as evidence of the potential significance inherent in all things as bearers of coded and decipherable messages. 15th-century hieroglyphics, heraldry and Baroque iconology are all documented in an extraordinary wealth of publications, bearing witness to a profound belief in the fundamental kinship of word and image that forms the basis for an im-

1601 — Henry IV founds the Royal Tapestry Manufactory in the Gobelin family dye works in Paris
1605 — The Dutchman Willem Janszoon discovers Australia 1607 — Monteverdi composes the opera *L'Orfeo*

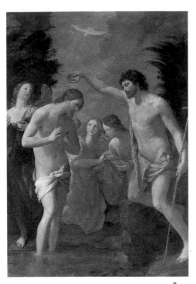

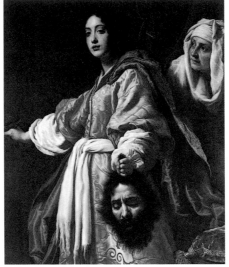

2 3

perturbable faith in the universal legibility of all natural and man-made signs.

These otherwise constant factors were to play a new and unique role in Baroque art, primarily because of the era's hitherto unparalleled capacity for synthesis, as so powerfully manifested in the Baroque "grand scheme", which not only sought a fusion of architecture, sculpture, painting and ornamentation such as we may find in churches and palaces, but also arranged festivities and celebrations to unite the arts in a sacred and secular ceremony, enriching them with music, poetry and dance. Today, all we tend to see of the Baroque grand scheme is the shell, magnificent as it may be, which served as a lavish setting for those temporary festivities that breathed life and cohesion into the *Gesamtkunstwerk* or total work of art. This pursuit of ceremony and ephemeral pageantry may be regarded as a specific characteristic of the Baroque era. The dynamic movement so frequently associated with Baroque art can be found in its exuberant façades and interiors, in the soaring figures that whirl through teeming ceiling paintings as though propelled by some supernatural force, and in the emotional expression of their faces and gestures; it is aimed at breaking down the contradiction between transience and permanence in a way that could be achieved only symbolically within the scope of pompous ceremony. No other era was so keenly aware of the fragility of earthly bonds. It is no coincidence that enormous intellectual and material investments were made time and time again in temporary structures, visual programmes and decorations for triumphal processions and ceremonies, *trionfi* and *entrées solennelles* as well as for the *castra doloris* structures built for funeral services.

This seeming paradox of what might best be described as "ephemeral monuments" reached its zenith in the Baroque love of fire-work displays. Unlike today's firework displays, these were distinctly pictorial, and their planners and designers enjoyed as much esteem as the best and most highly regarded artists. The people of the Baroque age would have made no distinction between "art" and the magnificent artifice of a firework display, for the purist 19th-century notion of art that was to break the *Gesamtkunstwerk* down into its individual component parts was still a long way off.

ɴew pictorial themes

Any attempt to determine the specific differences – apart from individual stylistic criteria – between Baroque art and the eras that went before it must take into account the great widening of thematic fields that occurred at that time. Unlike Mannerism, Baroque painting achieved some genuine innovations. The things that Baroque artists found worthy of portraying were no longer restricted to religious and secular history, portraiture and allegory – all of which focused on a classical concept of the liberty and greatness of man. The visual world of the Baroque explored new areas: apotheosis and state portrait, landscape, genre and still life, caricature and anamorphosis (deliberate distortion or elongation of figures).

None of these tasks was entirely new in itself, and all of them had forerunners. What was new, however, was that what had once been the extreme had now become the accepted form of an era. A common feature is that, although all are based retrospectively on the humanist visual concepts of the Renaissance with its anthropocentric principles, they nevertheless invariably point beyond these. For example, *The Apotheosis of St Ignatius* by Baciccio (1639–1709) is not

1611 — The monetary economy increasingly supplants the barter economy
1615 — Cervantes' *Don Quixote* is published in two volumes 1616 — Copernicus' astronomical writings are banned by the Church

8

2. GUIDO RENI
<u>The Baptism of Christ</u>
c. 1623, Oil on canvas, 263.5 x 186.5 cm
Vienna, Kunsthistorisches Museum

3. CRISTOFANO ALLORI
<u>Judith with the Head of Holofernes</u>
1613, Oil on canvas, 139 x 116 cm
Florence, Galleria Palatina

4. BACICCIO
<u>The Apotheosis of St Ignatius</u>
c. 1685, Oil on canvas, 48 x 63.5 cm
Rome, Galleria Nazionale

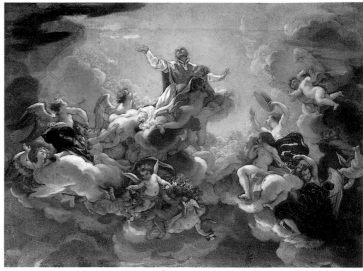

4

so much a glorification of the saint himself as a glorification of the Jesuit order; and when Charles Le Brun (1619–1690) portrays Chancellor Séguir in a ceremonial procession in the full regalia of his office (ill. p. 56), it is not the person of the Chancellor who is manifested in this state portrait, but the concept of the absolutist state as such. The landscapes of Annibale Carracci (1560–1609) or Nicolas Poussin (c. 1593/94–1665) may not be entirely devoid of human life, but they are innovative in that they present a landscape untamed by human hand and one that seems to possess an independence and autonomy far beyond the scope of its pictorial role as the mere setting for an event. In many ways, the genre painting also goes beyond the boundaries of the individual. The art critics of the 19th century quite rightly referred to this as a "social portrait" and the findings of more recent art historiography confirm that interpretation in revealing the moral or universal significance behind the scenes of everyday life. The same applies to the highly popular still life painting which expressly excludes all human participation and whose frequently edifying significance is cloaked in a veritable cult of sensuality. The Renaissance notion of the great and beautiful human individual is decisively countered by the Baroque love of anamorphosis and caricature, whose "invention" and dissemination originated in the school of the Carracci. The comic and the ridiculous have remained a legitimate and inalienable aspect of art ever since.

Finally, there is a singular phenomenon of Italian and German Late Baroque that deserves mention here: the *bozzetto* as an independent work of art. A bozzetto is generally a small painting sketchily executed as a draft in preparation for a mural or ceiling painting and often used as the basis for a contract between patron and painter. One example of this is Baciccio's *bozzetto* of *The Apoth-*

eosis of St Ignatius (ill. p. 9). Yet from these rather humble and entirely functional beginnings, the bozzetto gradually took on an independent value, becoming a collectors' item and a gallery object in its own right. A kind of interim zone was thus created – neither fresco nor panel painting – without encroaching upon any of the intentions, aims or functions of painting in other areas. In this respect, the bozzetto is an independent creation in which the widely divergent intentions of the Baroque meet and merge: the monumental and the intimate, the sketchy drawing with its fleeting brushwork and the richly coloured texture of the completed fresco, the transportable framed panel painting and the vision of celestial expanses. It combines the ephemeral and the permanent, the fluid and the firm, immutability and metamorphosis. The bozzetto is a painting in the making, its very state of work-in-progress constituting a form in its own right, and imbued with an inherent potential that epitomizes a highly specific aspect of Baroque visuality.

Whereas Renaissance artists concentrated on the problem of imagery in terms of the problem of portraying God's creation of man after his own image, the artists of the Baroque era sought to transcend the natural world with the aid of certain artifices, dramatic and extroverted pathos and illusionism on the one hand and extreme close-up, internalization, alienation and distortion of reality on the other hand. The illusionism of *trompe-l'œil,* the artifice of sophisticated technical innovations and the miraculous world of the stage set with its mechanical devices were as much a part of these means as the notion of transposing the whole life of a ruler such as Louis XIV (1638–1715), his palace, his court and the entire state into another, allegorical reality – that of the sun-state and the sun-king. The allegory is an essential and fundamental element of Baroque visual con-

1618 — Start of the 30 Years War with the Defenestration of Prague
1620 — Tobacco consumption spreads rapidly within Europe

1619 — The Habsburg Ferdinand II becomes Holy Roman Emperor
1622 — Birth of Jean Baptiste Pocquelin, known as Molière

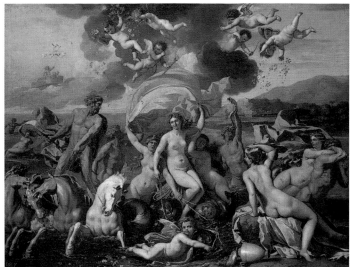

5. NICOLAS POUSSIN
<u>Triumph of Neptune and Amphitrite</u>
1634, Oil on canvas, 114.5 x 146.6 cm
Philadelphia (PA), Philadelphia Museum of Art

6. CLAUDE LORRAIN
<u>Moses Rescued from the Waters</u>
c. 1639/40, Oil on canvas, 209 x 138 cm
Madrid, Museo del Prado

7. SIMON VOUET
<u>The Toilet of Venus</u>
c. 1628–1639, Oil on canvas, 183.8 x 153 cm
Cincinnati (OH), Cincinnati Art Museum

5

cepts. Baroque allegory involves rather more than mere personification in the sense of visualizing an abstract concept or situation by endowing a human figure with certain attributes. Indeed, one might say that the extension of allegorical functions into the fields of landscape, genre, still life and caricature are all part of the iconological style of the Baroque. Allegorically conceived figures, scenes and metaphors were used as components of pictorial programmes of great complexity, varying from country to country in accordance with the respective needs and projections of the various nations, which were beginning to emerge more distinctly than ever before in the 17th century. A particularly fine example of this is the ceiling fresco by Pietro da Cortona (1596–1669) for the great hall of the Palazzo Barberini in Rome (1633–1639), which has come to be regarded as a work that opened a new chapter in Baroque decoration. Its portrayal of the fame of the Barberini as a gift of Divine Providence is the centre and focal point of this large-scale composition. The entire picture is an allegory glorifying the pontificate of the Barbarini pope Urban VIII. Painted architectural elements, ornaments and painted sculptures form an organizational structure within which the secondary elements of the programme designed by the Barberini court poet Francesco Bracciolini (1566–1645) are distributed. The fresco includes every form of painting: allegory and history, myth, landscape and even still life.

The great synthesizing power of the Baroque visual concept is not only expressed in the iconography of such allegorical "marriages", but is also immediately and sensually palpable in the relationship between the disciplines. Architecture and painting were united in a new overall visual concept. In the Renaissance, paintings were either integrated into an architectural framework that strictly respected the architectural boundaries or else they were conceived perspectively as views through a window. Certainly, there were already inherent similarities: painting had adopted architectonic, sculptural and decorative elements. The Baroque, however, brought a mutual interaction between painting and architecture, with light being handled in such a way as to create a smoothly continuous transition from built environment to illusionistic space. In the Baroque era, architecture itself became highly pictorial, and can indeed be best appreciated with this in mind. Admittedly, this is only one of the possibilities opened up by Baroque painting, for at the same time the process of pictorial autonomy, one of the most far-reaching innovations of the Renaissance, was being pursued even more radically. It was not until the Baroque age that the works so aptly described as "cabinet paintings" became widespread. These cabinet paintings had no specific cult or propaganda function and were sought solely as works of art for collection. Indeed – and it is this that is new – this was the sole purpose for which they were produced. The great Roman collections of the 17th century, those of the Giustiniani or the Barberini, indicate that paintings were not purchased and grouped according to motif and content, but coveted instead for their artistic value, their rarity and the fame of their creators.

Rome as the capital of the Baroque

This newfound possibility of regarding art primarily as art for its own sake opened up a whole new dimension of further and predominantly aesthetic potential for synthesis involving conscious references to other artists and their styles. In the early stages of the Baroque,

1622 — Diego Velázquez is appointed court painter to the Spanish royal family
chief minister and promotes absolutism as a form of rule 1624 — Cardinal Richelieu becomes Louis XIII's
1626 — Consecration of St Peter's in Rome, the largest church in Christendom

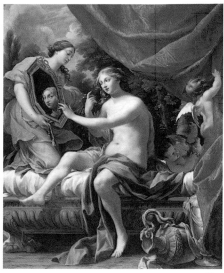

> "The colours in painting are flatteries, as it were, intended to seduce the eyes, just as in poetry the beauty of the verse is a seduction for the ears."
>
> Nicolas Poussin

6

7

Rome was the place where the decisive structures of a "Renaissance of the Renaissance" began to take shape. The fact that the Baroque emerged in Rome remains a valid tenet in the history of stylistic development. Yet whereas architecture developed along more or less continuous and uniform lines – the architectural history of St Peter's or Il Gesù springs to mind – early Baroque painting ran a considerably more dramatic and incalculable course. Annibale Carracci, with his studio of family members and academic artists, and Caravaggio, tend to be regarded if not as rivals, then at least as opposites in terms of artistic thesis and anti-thesis. Indeed, anyone who has visited the Cerasi chapel in Santa Maria del Popolo and has seen Caravaggio's *Crucifixion of St Peter* (1601) and his *Conversion of Saul* (1601) together with Annibale Carracci's *Assumption of the Virgin* (1590) immediately realizes that one of the most exciting challenges taken up by the subsequent generation of painters must surely have been the quest to unite the dramatic "tenebroso" of the artist from Lombardy with the Neoclassical grace of the artists from Bologna.

Annibale's decoration of the Galleria Farnese (ill. pp. 4 and 33) was to be of seminal importance to Roman and Baroque monumental painting. The return to monumentality played a decisive role in itself. On the other hand, Caravaggio's handling of great themes with humility was equally significant. The heightened realism of the large-scale work went hand in hand with the increasing realism invested in exploring the trivial, the everyday and the ordinary. Different as these two starting points may be, both are based on compositional inventions of the High Renaissance. Giorgione, Titian, Raphael, Michelangelo and Correggio are the names that must be mentioned here as "forefathers" of the Baroque. Yet it was Rubens, perhaps the most universal visual thinker of the Baroque age, who was the first to succeed in

drawing all these sources together in a true synthesis and establishing them throughout the courts of Europe.

It is frequently and quite rightly stressed that a general weariness and dissatisfaction with late Mannerist formal conventions may well have contributed towards certain reforms. Early Baroque in Rome may justifiably be described as anti-Mannerist. One key concept – the rediscovery of an idealistic natural portrayal based on High Renaissance art – could already be found in the work of Francesco Barocci (c. 1535–1612) of Urbino, even before the Carracci studio adopted it as the mainstay of their artistic programme. Caravaggio's rigorous realism, on the other hand, is programmatic in the sense that he broke with the classical ideals which Mannerism had stripped of meaning; the ideals of *buon costume*, of *invenzione*, of *disegno*, of *decoro* and of *scienza* (invention and draftsmanship, pleasing decor and scholarship), as Caravaggio's most vehement critic, Giovanni Pietro Bellori (c. 1615–1696) claimed.

It was in Rome, however, that the paths of Italian, French, German and Netherlandish artists were to cross. National characteristics were more clearly articulated in the Baroque era than ever before. Only the city whose cosmopolitan open-mindedness and generous patronage had captivated so many artists failed to create its own local style of painting; the international talents who lived in Rome and fuelled its role as myth, topos and idea were far too diverse and independent for that. These artists closely studied the latest contemporary trends whose sheer diversity called for synthesis, as embodied in the didactic concept of the Carracci studio and in the rough-shod maverick approach of Caravaggio. Rome was not a historically transfigured city of dreams echoing with the plaintive cry of its ruins, but a vibrant metropolis where temporal and spiritual patrons of almost decadent liber-

1630 — Gustaf II Adolf of Sweden lands on the Pomeranian coast and falls at Lützen (Saxony) in 1632

1633 — Martin Opitz publishes his *Trostgedicht in Widerwärtigkeit des Krieges*

8

ality set the tone and whose individuality made any attempt at establishing a single early Baroque style impossible. To divide the artists of the day into the followers of Caravaggio on the one hand and the followers of the Carraccis on the other, would be all too simplistic and quite misleading.

Though the Carracci students Francesco Albani (1578–1660) and Domenichino (1581–1641), and the Caravaggio-influenced artists Carlo Saraceni (c. 1580/81–1620) and Guercino (1591–1666) often tend to be played off against each other, such comparisons merely outline a very general trend. After all, not only was there a degree of mutual esteem between these artists, but their successors also found a lasting and fertile source of inspiration for the development of Baroque painterly form in a combination of their extraordinarily innovatory achievements. Indeed, the very notion that it is impossible to unite idealists and naturalists is a doctrine that emerged relatively late and one that has remained beyond the bounds of artistic practice. Even in the œuvre of such an archetypal classicist as Guido Reni (1575–1642), there is a considerable body of evidence bearing witness to the intensity with which he studied the work of his "opponents".

Only for a very few highly independent talents such as Adam Elsheimer (1578–1610) or Velázquez did the question of association with one particular school or certain dominant influences play no role at all. The same is true of Pietro da Cortona, that master of Roman fresco painting who was also a distinguished architect and an experienced sculptor. He was a decorative painter of the highest stature: not only did he apply architectural and sculptural elements as painterly elements, but he even combined painterly and sculptural components.

While it is undoubtedly true to maintain that specifically national schools did not emerge until the Baroque, we can also say with some justification that the international exchange of ideas and fluctuation of artists had never been so intense. It was a time of expanding horizons, assisted by the spread of printed reproductions which made a number of pictorial inventions – admittedly without colour – more rapidly accessible and available to a broader public. Rubens employed engraving studios which made his compositions famous throughout Europe. Many painters also began exploring the possibilities of printing, using it to create their own independent pictorial compositions, resulting in new inventions such as mezzotint and aquatint which soon found a place alongside more current techniques of engraving and etching.

It seems as though this internationalization of European painting in the Baroque, triggered by all these factors, also led to a distinct articulation of national schools, for it was only now that artists had the possibility of choosing from a huge range of old and modern art. The choice of an inspirational model may well have been the decisive factor that kept both the microcosm and the macrocosm of Baroque art in perpetual motion. It is the constant topic of all academic and educational reflections – from the Accademia degli Incaminati of the Carracci to the Parisian Académie Royale, where a vehement debate raged between "Rubenists" and "Poussinists" regarding the predominance of colour or line. For the individual artist, this choice was as existential and decisive as it was for the commune or the prince who determined prevailing taste through his patronage and who frequently sealed the fate, overnight, of artists who had fallen out of favour. Few nations famed for their distinctive artistic culture are so unequivocally indebted to the importation of foreign influences – in this case Italian and Flemish – as France. Yet what could be more French than the

1634 — Albrecht von Wallenstein, generalissimo of the imperial troops, is murdered by officers at Cheb (Hungary)
1635 — Cardinal Richelieu founds the Académie Française

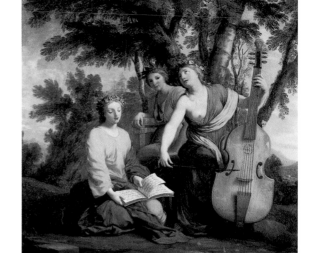

8. LOUIS LE NAIN
La Charette (The Cart)
1641, Oil on canvas, 56 x 72 cm
Paris, Musée National du Louvre

9. EUSTACHE LE SUEUR
Melpomene, Erato and Polyhmia,
c. 1652–1655, Oil on canvas, 130 x 130 cm
Paris, Musée National du Louvre

9

timeless landscapes of Claude Lorrain (1600–1682), the heroic harmony of man and nature in the work of Poussin, the crisp portraiture of Philippe de Champaigne (1602–1674) or the mathematical clarity in the still lifes of Lubin Baugin (c. 1610/12–1663)? Their origins in the work of Domenichino and in the art of Flanders and Holland may be proven, but it is not the decisive factor. It was the power of transformation that breathed life into the very substance of art and shaped the face of French Baroque. The incredible capacity for metamorphosis that astounded his contemporaries in the work of Sébastien Bourdon (1616–1671), an artist who could fool even the connoisseur with his paintings in the style of Poussin, the Le Nain brothers, or an Italian or Dutch painter, is a phenomenon of crucial importance not only in terms of an individual artist's personal choice of role model but also in terms of France's position with regard to the sources of Baroque painting. It certainly sheds some light on this aspect of the era. The purist cult of genius we have inherited from the 19th century has given us a tendency to disparage such phenomena as mere eclecticism, hampering our understanding of the complex processes that informed the stylistic creation of the Baroque.

Of all the explanations offered in an interpretation of Baroque history, there are two which have become firmly established, both for good reason. The first regards Baroque as the style of the Counter-Reformation. As long as the forms of Protestant Baroque are not ignored and as long as the Counter-Reformation is not regarded as the seminal principle from which a certain style emerged, but which willingly adopted that style as a convenient instrument of religious propaganda, this interpretation is acceptable. It is, after all, remarkable that such influential figures as the reformist popes Pius V (1504–1572), Gregory XIII (1502–1585) and Sixtus V (1521–1590) as well as the great founders of religious orders Thomas Cajetanus (1469–1534, Ignatius of Loyola (1491–1556), Filippo Neri (1515–1595) and Carl Borromäus (1538–1584) seem to have lacked any artistic policy pointing specifically towards the Baroque.

The second political theory is similarly flawed. It regards Baroque art as the perfect expression of absolutist claims to power in the state. This functional equation is also acceptable as long as we bear in mind that the early absolutist states – such as Florence under Cosimo I de' Medici (1519–1574) in the second half of the 16th century – were not actually centres of early Baroque art, and that the origins of this style are to be sought instead in Bologna and Rome, far from the ideals of the absolutist sovereign and the absolutist state of the 17th century.

France

A classic example of Baroque art in the service of absolutism can be found in France under the reign of Louis XIV. For the early Baroque period of the first half of the 17th century, developments in France were of little significance. The French sun did not rise until the second half of the century and, when it did, it shone with a brilliance and exemplary power that dazzled the aristocracy of Europe. It is tempting to surmise that it was only through the example of France that Baroque became the absolutist style – that is, if it can be described as a style at all. Though it was by no means new for art, and indeed all the arts, to be used as a vehicle for political ideals, never before had this purpose been organized to such perfection through insti-

1644 — Descartes, writing on the principles of philosophy, formulates the statement: *Cogito ergo sum* (I think, therefore I am)
1645 — Onset of the "Little Ice Age", a period of climatic cooling that lasts until 1715

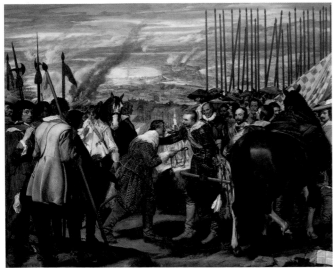

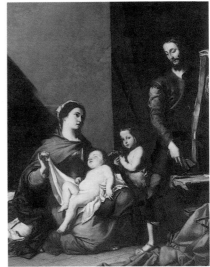

10 11

tutions and directors wielding so much power nor through projects on such a grand scale.

When Louis took the reins of power in 1661 following the death of the French chief minister Cardinal Jules Mazarin (1602–1661), thereby reuniting monarch and state in one person, he chose Jean-Baptiste Colbert (1619–1683) as his advisor in matters of art. Colbert began in 1663 with the reorganization of the Manufacture Royale des Meubles de la Couronne, which was entrusted with producing all manner of luxury furnishing and decoration, including tapestries. At the same time, Colbert acted as the political head of the Académie Royale de Peinture et de Sculpture, founded in 1648, whose artistic director was Le Brun, and in doing so he made the academy an instrument of royal artistic policy. Appointed *surintendant des bâtiments* from 1664, Colbert founded the Académie Royale d'Architecture in 1671 and was henceforth in charge of supervising all architectural projects and training new architects. In 1666, this process of centralization culminated in the creation of the Académie de France in Rome, a move that distinctly curbed the freedom of artistic life in the eternal city by exercising greater control over the French students there. At the same time, however, this same institution gave Paris a firm foothold in the promised land of art, on which it subsequently based its claim to a role as the "second Rome" in matters of art. Bernini's failure in Paris is also to be regarded in the light of this particular situation.

Baroque art is inextricably linked with the concept of the academy, and consequently with academic theory and debate, even to the point of pursuing theory as an independent discipline without necessarily requiring that it should have any effect on actual art policy. One example of this can be found in the famous debate, mentioned above, between the Rubenists and the Poussinists (in reference to their respective symbolic figureheads Rubens and Poussin) regarding the superiority of colour or line in painting. The key factor in this respect – a feature of the Baroque in general, as it were – is in fact the principle of polarity, along very much the same lines as the rivalry that had previously erupted between the "eclectic" followers of the Carracci and the "naturalistic" followers of Caravaggio in Rome, albeit under somewhat different circumstances. Whether a colourist such as Jean-Antoine Watteau (1684–1721) may seriously be considered in terms of this theoretical debate and the triumph of colour over line must remain an open question. Although he may have been the only French painter to have seen in the works of Rubens an inherent coloristic kinship-by-choice, whereas a Rubenist like Pierre Mignard (1612–1695) went no further than superficial adaptation, Watteau's ground-breaking work had already begun to pave the way towards a new era that found itself weary of the *grand goût*.

As regards the equation of Baroque and absolutism mentioned above – which, while not entirely incorrect, is certainly not unproblematic – it cannot be denied that a significant proportion of French painters went their own way, ignoring centralized art policies. Ironically, the very artist who was seminally important to the Neoclassical doctrine, Poussin himself, the epitome of French painting during the 17th century – a century which the French often refer to as their "golden age" of painting – was so deeply disappointed by Paris (to which he had been summoned as court painter by Louis XIII) that he returned within the space of just eighteen months to Rome, the city that had also become the chosen home of Claude Lorrain. Nevertheless, even at such a distance, both these artists were to exert an influence on the spirit of French painting that would prove to be more lasting and pro-

1648 — The Peace of Westphalia is agreed between France, Sweden and the Holy Roman Empire, bringing to an end the era of wars of religion. The modern concept of supra-confessional nation states is born

10. DIEGO VELÁZQUEZ

<u>The Surrender of Breda</u>
1634/35, Oil on canvas, 307.5 x 370.5 cm
Madrid, Museo del Prado

11. JUSEPE DE RIBERA

<u>The Holy Family</u>
1639, Oil on canvas, 253 x 196 cm
Toledo, Museo de Santa Cruz

12. BARTOLOMÉ ESTEBAN MURILLO

<u>The Pie Eaters</u>
c. 1662–1672, Oil on canvas, 124 x 102 cm
Munich, Bayerische Staatsgemäldesammlungen,
Alte Pinakothek

"In the poverty and half-dressed state of these boys there radiates, in their full feeling of health and love of life, nothing but inner and outer cheerfulness and utter freedom from care, such as a dervish cannot achieve better. Murillo's urchins have no other aims or interests, but crouch on the ground not out of listlessness but happy and blessed like the olympian gods."

Hegel on *The Pie Eaters*

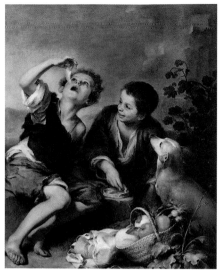

12

found than any of their colleagues residing in Paris, including Le Brun himself.

Independent, but no less highly esteemed, were the Le Nain brothers Antoine (c. 1588–1648), Louis (c. 1593–1648) and Mathieu (1607–1677), Georges de La Tour (1593–1652) and last but not least, the great engraver Jacques Callot (c. 1592/93–1635), whose cycle *The Horrors of War* produced in 1632/33 held up the cracked mirror of negative counter-image against the sovereign claim to the glorification of politics through art. The non-academic tendencies in French painting were powerful indeed. Their realism, inspired by Caravaggio, enjoyed not only bourgeois approval, but occasionally gained royal acceptance as well. Louis XIV even had all the paintings removed from his room and replaced by a single work: Georges de La Tour's *St Sebastian* (ill. p. 49). In his bedroom, he had five works by Valentin de Boulogne (1594–1632) and what is more, the king had also purchased paintings by Caravaggio.

Naples

In considering these two very different centres of Baroque painting – Rome and Paris – we should not forget the third major centre, Naples. The city had only recently taken on such a role. Before the 17th century, the painting here had barely achieved European stature; the city had no independent artistic tradition that might have triggered a new movement in the way the High Renaissance had emerged in Rome. It is for this reason that Neapolitan Baroque painting also lacks the harmonizing classical touch that might have moderated its tendency towards audacious non-conformity. An important aspect is the fact

that Caravaggio spent some time in this city, where he created the masterpieces of his later style. His chiaroscuro and his earthy realism were to pave the way for the entire century. Interestingly, although Domenichino and Giovanni Lanfranco (1582–1647) also spent some time in Naples, this seems to have had no particular influence.

A unique feature of Neapolitan art of the period is the dissolution of pictorial structure into a pattern of daubs of colours referred to as *macchia*, for which its exponents are described as *macchiettista*. This sketchy style of painting, sometimes erroneously referred to as "impressionistic", is the stylistic instrument of an improvisational and virtuoso painting which does not concern itself with iconographic content, but concentrates instead on presenting cavaliers in battle, bawdy *bambocciata* and genre scenes from the lives of soldiers and vagabonds. The leading representative of this style is the painter and poet Salvator Rosa (1615–1673), who was a brilliant master of all thematic fields and whose particular speciality was battle scenes. Of all the painters of the era, he may certainly be described as the one with the most flamboyant imagination. He has left us as his heritage the unforeseen, fickle and unpredictable stroke of the imagination that has come to be known as the *capriccio*. Since Salvator Rosa, it is impossible to think of Baroque painting without the capriccio.

The most popular representatives of Neapolitan Baroque painting have always been Mattia Preti (1613–1699) and Luca Giordano (1634–1705), known to his contemporaries as "fa presto" in reference to the prodigious speed at which he is said to have painted. Giordano is acknowledged as a great Neapolitan fresco painter who went beyond the scope of local style, exploring Roman influences, especially that of Pietro da Cortona. The importance of Naples in the field of Baroque painting is further enhanced by a curious circumstance: the

1648 — Cardinal Jules Mazarin, French chief minister, founds the Académie Royale de Peinture et de Sculpture in Paris 1649 — The manufacture of chandeliers and mirrors begins in Venice 1650 — The persecution of witches in Central Europe has passed its height

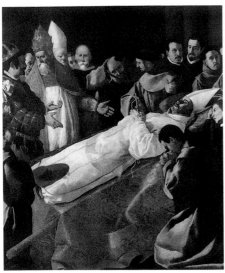
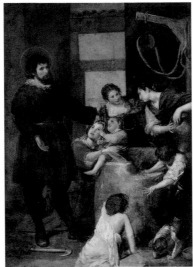

13 14

city's position as a Spanish dominion. Naples would play an influential role in the development of Spanish Baroque painting and would be an important source of inspiration for its painters. A key figure in this respect is the Naples-based Spanish artist Jusepe de Ribera (1591–1652), the main exponent of Neapolitan Caravaggism.

spain

Certain external factors have to be taken into consideration when addressing the subject of Spanish Baroque painting. First of all, we should bear in mind the extremely low social status of painters, a situation against which the generation of Spanish artists following El Greco still continued to struggle. Much of our information about their lot comes from El Greco's own no longer fully extant writings on architecture, sculpture and painting, together with the modest 17th-century contributions of Francisco Pacheco (1564–1654), Vincente Carducho (c. 1576–1638) and Juan Bautista Martínez del Mazo (1612–1667), whose writings were also aimed at enhancing the social stature of artists – an aim that had already borne fruit in Italy a full two centuries previously. Dependent as Spanish painters were on outside contacts in order to keep pace with artistic developments in Italy and the Netherlands, they themselves had very little influence on the rest of Europe until the 19th century. This is due to the circumstances which also shaped the specific physiognomy of Spanish Baroque. Its "golden age" coincided with the Spanish government's progressive loss of power and prestige. Such events as the defeat of the Armada by the English, dealing a fatal blow to Spain's marine power, the ceasefire negotiated with Protestant Holland in 1609 after a long and

wearing struggle, and the eventual recognition of this small country's independence in 1648, are only the most spectacular outward signs of the decline and fatigue that had gripped the country as the result of decades of aggressive power politics.

The Spanish court under Philip II (1527–1598) had few commissions to award that would have been attractive to foreign artists. Though Rubens did produce a number of works in Madrid, we should remember that this Flemish artist was working in the service of the crown as a Spanish subject and a diplomat.

Apart from representative, prestigious and diplomatic portraits, the only works commissioned by the Spanish court were the cycles of battle paintings for the Salon de Reinos, Francisco de Zurbarán's (1598–1664) *Hercules* cycle, and the mythologies for the royal hunting lodge of Torre de la Parada executed by the Rubens studio. This lack of courtly commissions and the low social status of artists in Spain are two important factors which were further exacerbated by an absence of aristocratic and bourgeois patronage. The Spanish nobility led a distinctly Don Quixotic life and the repertory of Baroque themes held little appeal for them as they tilted at windmills to escape the reality of their own insignificance. Only the Church felt an increased need for paintings, and welcomed the stylistic devices that had emerged in the Roman Counter-Reformation. Cloyingly sweet *Immaculadas* – an iconographic speciality since El Greco – the delicate portrayals of the infant Jesus by Bartolomé Esteban Murillo (c. 1617/ 18–1682) and the austere, enigmatic portraits of saints by Zurbarán represent the extremes of Spanish religious painting in this era.

The advent of Caravaggism also acted as an important stimulus on Spanish art, where it fell on the fertile soil of a local chiaroscuro technique based on Netherlandish and late Mannerist painting. In

13. FRANCISCO DE ZURBARÁN
The Lying-in-State of St Bonaventure
1629, Oil on canvas, 245 x 220 cm
Paris, Musée National du Louvre

14. ALONSO CANO
St Isidore and the Miracle of the Well
c. 1646–1648, Oil on canvas, 216 x 149 cm
Madrid, Museo del Prado

15. JUAN SÁNCHEZ COTÁN
Still Life (Quince, Cabbage, Melon and Cucumber)
c. 1602 (?), Oil on canvas, 65 x 81 cm
San Diego (CA), The Fine Arts Gallery of San Diego

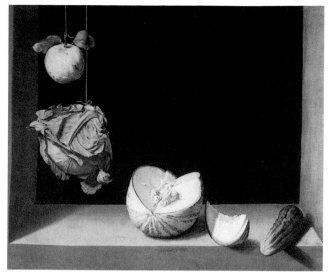

15

Seville, home to what was probably the leading Spanish school of painting in the 17th century, this produced a highly distinctive variation of earthy, brown-toned painting in which the colour structure of a canvas was reduced to its bare essentials, at times even paring it down to little or no colour so that each hue seemed to take on the function of a light intimately merged with the very substance of the paint itself. In Zurbarán's *The Ecstasy of St Francis* (Munich, Alte Pinakothek) it is no longer a sudden and glaring burst of light from some outside source that heightens the sense of supernatural emotional excitement as an accompanying rhetorical gesture; nor is there any natural source of light of the kind employed by the followers of Caravaggio to create their unnatural light effects. Zurbarán's chiaroscuro is inherent within the colours themselves, and the surfaces of his objects are bathed in it. In this merging of light, that most immaterial of all things, with the clay-like hues of the very humblest all materials – to be found in the earthy tones of so many portraits, still lifes and genre scenes – Spanish Baroque painting possesses a spiritual quality that lends it a unique position in European art.

Velázquez, in his early period, is also a highly original representative of this Spanish tenebroso. In an early work such as *The Water Seller of Seville* (c. 1620; London, Wellington Museum), he undertakes to transform a simple glass of water, ennobled by the cool and silvery breaking of the light, into an enigmatic and precious object and to reflect this in the sphere of experience of the characters. Velázquez turned briefly to the genre pieces of kitchens and cellars known as *bodegones*, but he never specialized in any direction and went on to expand his repertory beyond the routine commissions of court – portraiture, children's portraits, equestrian portraits – to such an extent that, apart from mural and ceiling painting, which played only a minor role in Baroque Spain anyway, his œuvre covers all the major thematic fields of the time. It includes the female nude in the form of the *Rokeby Venus* (c. 1644–1648; London, National Gallery), the only surviving example of four portrayals of Venus – an extremely rare subject matter in Spanish painting – as well as mythological and sacred history paintings and the great allegories of painting which he integrated into his *Weavers* (c. 1644–1648; Madrid, Museo del Prado) and into his famous portrait of the family of Philip IV known as *Las Meninas* (ill. p. 71).

In his time, Velázquez was a contemplative painter, a man of ideas and a thinker who upheld the value of human dignity as none had done before. His great painting of the *Surrender of Breda* (ill. p. 14) is not a picture of subjection, but of conciliation. Even in his portraits, so popular at court, of the dwarves, fools and idiots who were regarded at the time as living caricatures, Velázquez imbues these individuals with an undeniable dignity that brooks no mockery. In spite of these achievements, or perhaps precisely because of the personal qualities that produced them, Velázquez was nevertheless one of those artistic personalities whose path remained uniquely his own and drew so subsequent followers.

Germany

Whereas it was unusual for Spanish painters to travel to Rome and Italy (Ribera was the exception, and he never returned from Naples), it was common practice for German Baroque painters to spend as much as several years abroad in the Netherlands, Italy or even in both these countries. Leaving aside the greatest and most de-

1655 — With the Inquisition, in particular in Spain, France and Italy, people deviating from Church dogma are persecuted
1658 — Leopold I becomes Holy Roman Emperor 1661 — Louis XIV, the "Sun King", becomes absolute ruler of France

17

16. ADAM ELSHEIMER
The Flight to Egypt
1609, Oil on copper, 31 x 41 cm
Munich, Bayerische Staatsgemäldesammlungen,
Alte Pinakothek

17. JOHANN LISS
The Death of Cleopatra
c. 1622–1624, Oil on canvas, 97.5 x 85.5 cm
Munich, Bayerische Staatsgemäldesammlungen,
Alte Pinakothek

18. JOACHIM VON SANDRART
November
1643, Oil on canvas, 149 x 123.5 cm
Munich, Bayerische Staatsgemäldesammlungen,
Alte Pinakothek

16

cisive intervention in early Baroque artistic development in Germany, the Thirty Years War, we find the most important reason for the fluctuation of artists is their lack of a territorial centre of their own in the Holy Roman Empire of the German Nation which, as a capital city, might have been able to establish certain stylistic standards, creating some uniformity in German Baroque painting.

The German love affair with Venice begins with Hans Rottenhammer (1564–1625), who settled in that city in 1589. The Frankfurt artist Adam Elsheimer (1578–1610) joined him there and in 1600 both these artists were to find their chosen home in Rome. Venice was also the destination of the Holstein artist Johann Liss (c. 1595 – c. 1629/30) and the Munich artist Johann Carl Loth (1632–1698). Whereas Loth combined the Roman tenebrism of Caravaggio with a Venetian handling of colour, Liss brought Netherlandish elements with him from Amsterdam and Haarlem, integrating them into Venetian painting, of which these two German artists were regarded as the leading representatives in the 17th century. Their influence on German painting, at least in the case of Liss, was limited.

Other artists, such as Johann Heinrich Schönfeld (1609–1682), who passed on his Roman and Neapolitan experience on his return, had a more widespread impact as mediators of foreign schools of painting. One of the most significant results of this propensity for travel was Joachim von Sandrart's *Teutsche Academie der edlen Bau-, Bild- und Mahlerey-Künste* ("German Academy of the Noble Art of Architecture, Sculpture and Painting") published in Nuremberg in 1675–1679. It is an invaluable source of theoretical and historical documents comparable to Vasari's *Lives of the Artists* and may be regarded as a fundamental work of German art historiography.

Sandrart, a highly esteemed artist and a respected authority, had founded an academy in 1662. At his initiative, it was situated in Nuremberg, but it was barely able to fulfil its intended function of an influential centre of art that could set standards. In the light of overall developments in Europe, and given the role played by the academies in other countries during this period, it came a little too late.

Andreas Prater

1662 — Charles Le Brun takes over the artistic direction of the Royal Gobelin Tapestry Manufactory
1666 — The Académie des Sciences is founded in Paris and publishes the first scientific journal in France

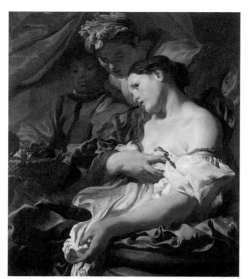

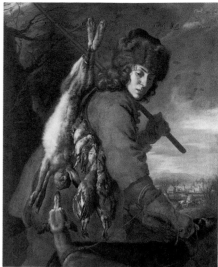

> "The landscape was so beautiful, the reflection of the sky in the water so natural, the travellers and beasts so very well drawn, that such a realistic style had never been seen before, and consequently Elsheimer's newly-invented art of painting was all that was talked about in Rome."

Joachim von Sandrart on
The Flight to Egypt

17

18

Baroque in the Netherlands

In the 17th century, following the division of the country, painting in the Netherlands blossomed in what came to be known as its Golden Age. Rubens in the Catholic south of the country and Rembrandt in the Protestant north represent the contrasts and kinships of Baroque painting at its zenith. Whereas Rubens, with his monumental creations for nobility and the Church, forged a link between the mortal, earthly world and the realms of Heaven or Olympus, Rembrandt's subtle chiaroscuro revealed the hidden depths of the human soul, creating a new dimension in portraiture. Alongside these artists of genius, we also find the outstanding portraiture of Frans Hals and van Dyck, the landscapes of Ruisdael, van Goyen and Hobbema, the allegories of Jordaens, the still lifes of Heda and Kalf, and the genre scenes of Brouwer, Steen, Terboch and de Hooch. The painting of the era culminates in Vermeer's luminous interiors – masterpieces in the handling of light and harmony of colour.

After Rembrandt was commissioned by Prince Frederick Henry of Orange (1584–1647) to paint five scenes from the Passion of Christ, most of which are now in the Alte Pinakothek in Munich, he corresponded between 1636 and 1639 with the Prince's governor-secretary Constantijn Huygens (1596–1687). In one of seven surviving letters, Rembrandt writes about the *Entombment* (c. 1636–1639), stating that he had taken great care to render "die meeste ende natureelstc bcweechgelickheijt" ("the greatest and most natural movement") and explaining that this was why he had spent so much time on the painting. This "greatest and most natural movement" of which he speaks in his letter refers as much to the subtle and realistic portrayal of the figures as to the expression of their inner emotion.

A Mannerist artist of the 16th century would have couched a description of his work in very different terms. He would have emphasized the skill, artifice and inventiveness of the painting. Rembrandt's comment referred to something else. It evoked a quality that was to become a fundamental feature of Baroque painting, particularly in the Netherlands. Rembrandt was talking about realism and about a new and more intimate approach to the way the world looks. He was also talking about a new dimension of pathos and expression – "natureelste beweechgelikheijt".

Rembrandt's *Passion of Christ* cycle is the early work of a Dutch artist. It coincides with the late work of the Flemish painter Peter Paul Rubens. Between 1636 and 1638, Rubens was working on a series of designs for a major mythological cycle, part of which he executed personally, that had been commissioned by the King of Spain to decorate the royal hunting lodge of Torre de la Parada near Madrid. Irrelevant as the all too frequent attempts to compare Rembrandt and Rubens may often be, they can nevertheless provide some interesting insights: what Rembrandt regarded as a commission, Rubens regarded as the enriching culmination of his life's work. In Rubens' later work, we find an increase in pathos and dramatic expression.

In Ruben's major paintings of the 1630s, from his altarpieces to his designs for civic stagings, such as the *pompa introitus* designed to welcome the Infante Ferdinand as regent of Flanders, from his mythological scenes to his landscapes, we find an increasing density and centrality. Each painting thereby gains significance from the attribution of essential characteristic and objects to its content.

Certain criteria of Netherlandish painting were clearly established even before Rubens and Rembrandt: realism and the faithful

1669 — The *Malleus maleficarum* ("The Witch Hammer"), one of the most widely published books of the day, goes into its 30th edition
1670 — Manufacture of the first clocks with minute hands 1673 — Louis XIV introduces the Allonge wig

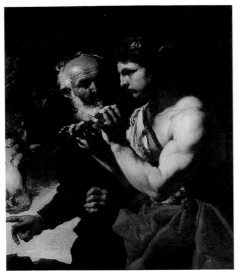

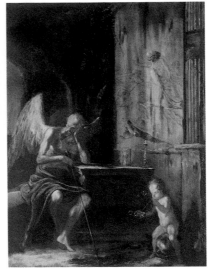

19

20

rendering of objects. Their contribution, however, is the presentation of pathos and movement; increased pictorial expressiveness achieved by centering and by profound handling of colour and light.

There are limits to the usefulness of any comparison between the late Rubens and the early Rembrandt, and such comparisons invariably tend to be used to highlight certain polarities. On the one hand, we have an aristocratic painter and cosmopolitan sophisticate sought after by the ruling houses of Europe and the Church. On the other hand, we have a miller's son from Leiden whose attempts at running a patrician house in Amsterdam are doomed to failure, and who eventually withdraws to the margins of the ghetto, avoiding human contact and devoting himself entirely to his painting. Yet both of them had an enormous impact on the world of art, becoming the masters of their century and forming schools of art – both literally and metaphorically – that shaped the development of painting. Moreover, they were the only artists in the Netherlands to practise every genre of painting, from history painting to portraiture; at the same time, they advocated a return to specialization in painting. Rubens trained and employed specialists for flowers, genre figures and even for "Rubens-style" painting. Virtually every Dutch specialist was equally indebted to Rembrandt, from "fine" painting to *trompe l'œil* illusionism and even portraiture.

The rise of painting in the Netherlands coincided with a period of political turbulence in which the country was divided once and for all both by religion and political rule. It was a period when Antwerp lost much of its wealth and power, just as Amsterdam's star was rising. The fact that Rubens was commissioned by the Church and the nobility was due to some extent at least to the fact that he initially had to look beyond the confines of Antwerp, to Italy, motherland of the arts, in

order to establish a name for himself. Under political pressure, Rubens' work became increasingly outward-looking, while the newly rich and proud city of Amsterdam boasted that Rembrandt had never been to Italy, and the latter's art became increasingly introverted and his radius of movement diminished in Amsterdam.

In 1566, the largely Calvinist Gueux who had revolted against Spanish rule sacked the Catholic churches and monasteries of Antwerp (at the time a city with a population of some 120,000) in a violent wave of iconoclasm. The Spanish rulers responded by calling in the Inquisition; Margaret of Austria, duchess of Parma (1522–1586) resigned from her post as governor-general, and troops headed by the Duke of Alba (1507–1582) marched in. Rubens finally return to settle in Antwerp in 1608.

In the Southern Netherlands, which had remained Spanish and Catholic, a certain degree of normality was beginning to return to everyday life, with churches and monasteries being rebuilt and restored. Thanks to the patronage of the art-loving Infanta Isabel Clara Eugenia (1566–1633), a sister of King Philip III of Spain (1578–1621), Rubens had a more than adequate supply of work from court, municipality and church.

Rubens' great historical achievement was his synthesis of the traditions of classical painting in a previously unimaginable way, one that created dynamic perspectives rather than statically retrospective structures. He was to become the painter of the new Baroque era, the exponent of an art that transcended the borders between reality and meta-reality, transforming the static props of the Renaissance into exuberantly theatrical scenes. He was to become the painter of a spiritual and worldly apotheosis, presenting by sensual means the deification of the great and the good, and their entry into the world of eternity and

1678 — Chrysanthemums are brought to Holland from Japan
1685 — The Protestant Huguenots flee abroad

1680 — Arcangelo Corelli is the first composer to write a *Concerto grosso*
1688 — Building work on the palace of Versailles is completed

19. JOHANN CARL LOTH

<u>Mercury Piping to Argus</u>
before 1660, Oil on canvas, 117 x 100 cm
London, National Gallery

20. JOHANN HEINRICH SCHÖNFELD

<u>Il Tempo (Chronos)</u>
c. 1645, Oil on canvas, 102 x 77 cm
Augsburg, Deutsche Barockgalerie im Schaezlerpalais

21. JOHANN MICHAEL ROTTMAYR

<u>St Benno</u>
1702, Oil on canvas, 118 x 100 cm
Munich, Bayerische Staatsgemäldesammlungen

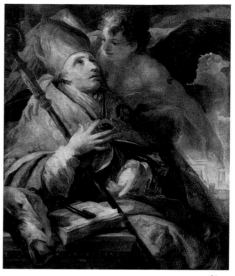

21

conceptuality. He adopted the *Assumption* or *Ascension* as his fore-most theme, in all its variations, creating for his ecclesiastical patrons of the Counter-Reformation images of beings ascending to celestial heights, or – for patrons in court circles – descending into the sphere of the sensually palpable.

When Rembrandt was born in Leiden in 1606, the northern provinces of the Netherlands – which were governed by stadholder Maurice of Nassau, Prince of Orange (1567–1625) – had only been fully independent of Spanish rule since 1596, under the terms of a truce that was to last until 1621. The Peace of Westphalia in 1648, which also marked the end of the Thirty Years' War, recognized the Northern Netherlands and at the same time separated them for good from the southern provinces, which remained Spanish, coming under Austrian rule in 1714.

The province of Holland took the leading role within the union of Zeeland, Gelderland, Overijssel, Drenthe, Friesland and Groningen. By closing off the Scheldt, Antwerp's access to the sea, Holland crushed the city which, in the 16th century, had been the wealthiest trading centre of the north, while Amsterdam rose to unprecedented prosperity. Holland rivalled England as a seafaring power, gaining a virtual monopoly on cargo shipping, dominating the Baltic grain trade and establishing colonial bases in the East Indies, West Indies, North and South America. Above all, Amsterdam was a flourishing centre of finance, and the importance of its "exchange bank" was comparable to that of Wall Street today. In 1602, a number of trading companies joined forces to create the Dutch East Indian Trading Company, triggering a hitherto unimaginable flow of money into Amsterdam.

The political structure of the States-General was federal, with the Princes of the House of Orange acting as stadholders or chief executives of otherwise self-governing republics in which a monied nobility of wealthy burghers emerged to take over the administration, deriving their legitimation from the liberation struggle and their financial success.

The process of political independence in the Netherlands was largely a religious struggle in which various forms of Protestantism, most notably Calvinism, took firm hold. A national synod held at Dordrecht in 1618 prohibited Catholic religious services and permitted only Calvinists to hold office. Most of the members of the House of Orange were orthodox Calvinists, and only scattered pockets of the northern provinces remained Catholic.

The history of the new northern provinces began with the iconoclasts. In his *Decalogue*, John Calvin had taken a stance on the question of imagery and had called for a ban on any representation of the divine. The almost sacramental dignity with which the Catholic faith had endowed the portrayal of saints had now become a sacrilege. This turn of events narrowed the field of artists' commissions by putting an end to church decoration and altarpieces.

When Rembrandt created his series of paintings on the *Passion of Christ* for the Prince of Orange, these were intended for private devotion. The landed nobility with their palaces provided few commissions for frescos or major decoration. The Orange palace of Huis ten Bosch was one of the few exceptions, albeit on a modest scale, and was decorated by Flemish painters. The extent to which the question of images was first and foremost a question of religious images is reflected in the fact that the production of paintings in the Netherlands grew enormously from the end of the 16th century and the balance between supply and demand became exceedingly complex. The now predominant genres showed that Christian iconography

1697 — After converting to Catholicism, Augustus II the Strong is elected King of Poland **1701 — England, the Netherlands and Austria conduct the War of Spanish Succession against France, Bavaria and Cologne for hegemony in Europe**

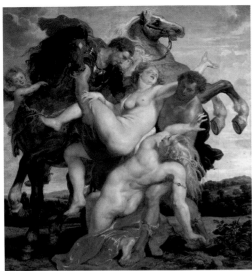
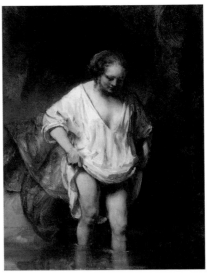

22 23

had not entirely disappeared from painting. As Calvin, in his doctrine of predestination, had accorded to each individual something akin to a personal priesthood, it was inevitable that the portrait, as the depiction of the individual, should take on a new significance. Accordingly, it became an outstanding instrument in Holland as well. The image of the individual, or of a group, also indicated the position of the individual between God and the world. Where the image of God was forbidden, the allegory was all the more important. Often, in Dutch painting, we find the so-called *portrait historié*, a specific likeness, generally of several people, but in a biblical or mythological role. For example, if two brothers were reconciled after a family dispute, they might commission a portrait depicting them in the roles of Jacob and Esau to celebrate their reconciliation.

What may appear at first glance in Netherlandish painting to be a genre scene – and was long regarded as such – is almost invariably an allegory or a pointer towards some accepted "truth". Scenes of gallantry and entertainment, originating in brothel scenes, have their roots in the parable of the prodigal son. Jan Steen (c. 1625/26 –1679) painted humorous scenes depicting folk wisdom, allegories or proverbs. The superficial humour could also be taken at face value. The Mannerist tendency to conceal the meaning of a picture by packaging it in a rebus or intricate puzzle, was adopted and presented, in the 17th century, in a less equivocal, simpler and more obvious form.

Probably the most striking example of the way in which the allegory took the place of the religious painting is the still life, and in particular the genre of the vanitas still life. The very designation "vanitas" (Lat. "vanity") tells us that the beautiful and pleasingly painted objects are an indication of the transience of all earthly life. The figurative

meaning of a skull or a dying candle is quite obvious, and we can easily deduce that a soap bubble is likely to symbolize the triviality of life. In a similar fashion, there exists a vast repertoire of symbolic meanings, many of which are no longer familiar to us today, with which the objects in other types of still life are endowed with specific significance. The frequent depiction of bread and wine in Dutch still lifes is, for example, an indication of the increasing use of secular surrogates to evoke the liturgical rites of the Eucharist. With the decline of religious imagery, allegorical painting flourished. However, this particular development was not restricted to the Protestant Netherlands alone. It could be found in the southern provinces, too, albeit with a considerably stronger affinity to Italian art and the traditional subject matter of Catholic painting.

Just as, in the course of the 16th century, paintings had become less and less an integral part of the architectural whole, particularly in the Netherlands, so too did the painting itself become a commodity as well as a transportable object. One indication of this development is the emergence of an art trade and exhibitions. We know that, by this time, painted canvases had become objects of speculation and that they were regarded as capital assets, accepted as payment and taken as security. With the increasing emancipation of the middle classes, the circle of buyers of paintings grew to an extent that would have been unthinkable in the early years of the 16th century when the Church, nobility and a small circle of humanist thinkers had commissioned works.

Sales exhibitions were first held in Antwerp, and in the course of the 17th century became commonplace throughout Holland. By 1640, the Guild of Painters in Utrecht had a permanent exhibition of works for sale. In The Hague, the painters formed a corporation for commer-

1705 — In the new, guild-free areas of industry, the "manufactory" becomes an increasingly common form of enterprise, sometimes employing over 1000 workers 1713 — The Peace of Utrecht marks the end of the War of Spanish Succession

22. PETER PAUL RUBENS

The Rape of the Daughters of Leucippus
c. 1618, Oil on canvas, 224 x 210.5 cm
Munich, Bayerische Staatsgemäldesammlungen,
Alte Pinakothek

23. REMBRANDT HARMENSZ. VAN RIJN

Hendrickje Bathing in a Stream
1654, Oil on oak, 61.8 x 47 cm
London, National Gallery

24. FRANS HALS

Two Singing Boys
1626, Oil on canvas, 62 x 54.5 cm
Cassel, Staatliche Kunstsammlungen

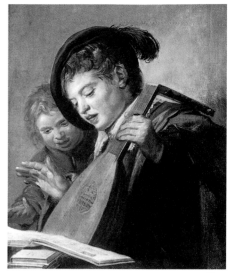

"My talent is such that no undertaking, however vast in size or diversified in subject, has ever surpassed my courage."

Peter Paul Rubens

24

cial purposes in 1656, and occasionally made attempts to standardize formats in order to rationalize sales and pricing. Even the Dutch picture frame became uniform and standardized. These ornate dark or black wooden frames were artistically formed, but also neutral and appropriate to the painting.

Whereas there had previously been agents who mediated between an aristocratic or ecclesiastical patron and the artist, the profession of art dealer now began to emerge, along with assessors and auctioneers, and Amsterdam became the centre of the art market. Painters frequently offered for sale not only their own works, but also paintings by other artists or antique works. We know, for example, that Rembrandt sold works by his students, and Arnold Houbraken (1660–1719), chronicler of 17th-century art, reports that Frans Hals exploited his student Adriaen Brouwer (c.1605/06–1638).

Result and cause of the newfound mobility of paintings was the increasing specialization of individual painters in specific genres and subject matter. Delegation of work was the rule, rather than the exception. Rubens is known to have had specialists for certain aspects of painting; Jan Brueghel (1568–1625) collaborated with him, painting the flowers in some of his works. Nicolaes Berchem (1620–1683) painted incidental figures in the paintings of Jacob van Ruisdael (c.1628/29–1682). On the other hand, a landscape painting by Berchem includes a portrait of a man and woman by the portraitist Gerard Wons. In the church interiors by Pieter Saenredam (1597–1665) we frequently find incidental figures by Pieter Post (1608–1669).

As painting became increasingly equated with the production of a commodity, the status of the artist threatened to return to that of mere craftsman, the very status from which artists had emancipated themselves in the Renaissance. Rubens and Anthony van Dyck (1599–1641) succeeded in establishing themselves as a new form of artist-aristocrat, though Rubens was once sharply cut down to size by a real aristocrat. Rembrandt's attempt at this kind of upward mobility was a rather tragicomic expression of a prototype Bohemian lifestyle.

Painters who took on other kinds of work, or part-time painters, became fairly commonplace. Jan van Goyen (1596–1656) traded in tulips and real estate. Many artists of the day, including Jan Steen and Adriaen van de Velde (1636–1672) were publicans who could exhibit paintings in their taverns and who occasionally accepted them in payment. Jacob van Ruisdael was a surgeon, Philips Koninck (1619–1688) had a shipping line, Meindert Hobbema (1638–1709) was a tax collector. Few of them found painting a lucrative occupation.

One of the many changes that swept the Netherlands in the turbulent years of the late 16th century, apart from the emancipation of the painting as such, was the fact that this "commodity" no longer needed to be a vehicle for a certain "content" in the traditional sense, but contained objects gathered together as genres. It became far less common for paintings to be commissioned on a particular theme. Instead, certain subjects tended to be preferred or rejected by purchasers. The concept of "subject matter" which became so important in the 19th century is best used here to describe what individual specialists now produced.

Understandably enough, orders were still frequently placed for individual and and group portraits, the latter being mainly for institutions and meeting halls such as the premises of the Civic Guards, where the painting had a permanent place.

1715 — Death of the Sun King Louis XIV subsequently at all the courts of Europe

1719 — Riding to hounds becomes a popular palace pursuit, first in France and
1721 — Johann Sebastian Bach completes his *Brandenburg Concertos*

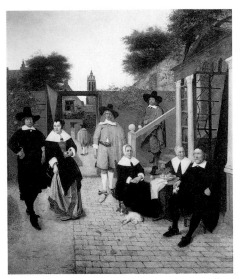

25

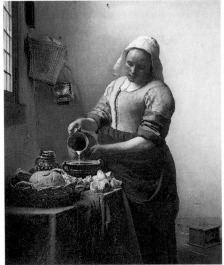

26

25. PIETER DE HOOCH
<u>Dutch Family</u>
c. 1662, Oil on canvas, 114 x 97 cm
Vienna, Kunsthistorisches Museum

26. JAN VERMEER
<u>The Kitchen Maid</u>
c. 1658–1660, Oil on canvas,
45.5 x 41 cm
Amsterdam, Rijksmuseum

27. JAN BRUEGHEL THE ELDER
<u>The Large Fishmarket</u>
1603. Oil on panel, 58.5 x 91.5 cm
Munich, Bayerische Staatsgemälde-
sammlungen, Alte Pinakothek

subject matter and content – specialists and masters

One of the greatest achievements of Netherlandish Baroque painting was its creation of specific schemes within the various genres, in which a great diversity of individual objects gained their own distinctive and unprecedented dignity. History painting ranked highest in the artistic hierarchies of the day. It referred to paintings which represented an "image of historic events" in which the actual portrayal of significant contemporary events played only a minor role. The painting by Gerard Terboch (1617–1681) depicting *The Swearing of the Oath of Ratification of the Treaty of Münster* of 1648 (London, National Gallery) is in fact a group portrait showing the representatives of the signatory power. Battles and other warlike events were rather less popular subjects, with the possible exception of equestrian combat. At the same time, however, history paintings could also feature allegorical subjects from Antiquity, especially if they involved republican subjects. Finally, history paintings might also be portrayals of biblical themes, particularly from the Old Testament.

Rembrandt addressed the Protestant variety of religious painting – the parable – in greater depth than any had done before, exploring the human factor as well as the divine. In the work of his students Flinck, Bol and Nicolaes Maes (1632–1693) this contemporaneity of the biblical and of man's relationship with God is more immediately evident, more direct and, in the *portrait historié*, often dramatically presented. Nevertheless, in Dutch history painting, the ambitious aim of projecting contemporary life onto a backdrop of historical or biblical events and, on the other hand, updating ancient or biblical paradigms, is often naive, if invariably human, in its directness. Flemish painters

such as Rubens or Jacob Jordaens (1593–1678) were, in a similar sense, history painters: the difference between them and the Dutch painters lies in the distinct sensuality and corporeality of earthly appearances they achieved through their heightened colour and form, suggesting and at times revealing a sense of meta-reality.

Since the 15th century, the portrait had become an independent genre. So, too, since Dürer and the High Renaissance, had the self-portrait of the artist. In the Netherlands of the 17th century, the portrait became the primary vehicle not only for the representation of a person's social rank and standing, but also an exercise in exploring the psyche through the individual's expression. What is more, the portrait now came to represent the relationship between the individual and the community, either in the form of a family portrait (of which Rubens created some that showed bonds of deep affection), or in the group portraits by the Dutch artists in which Hals, Thomas de Keyser (c. 1596/97–1667) and Rembrandt sought successfully to depict individuality within a homogeneous group. The developments of the age are all the more evident in the light of a comparison with the group portraits created before the mid-16th century, for example by Jan van Scorel (1495–1562). Initially, they generally involved an accumulative juxtaposition of portraits (of pilgrims to Jerusalem, for instance). In the work of Hals, the occasion, the principle and the essence of a group are the determining factors in its composition. After all, Rembrandt's *Night Watch* (ill. p. 85) is also a group portrait, albeit one in which the painter admittedly goes far beyond the conventions of this particular genre, creating a highly theatrical *mis en scène*.

With the increasing secularization of places of worship in the Netherlands and the loss of votive and sacred images in the wake of the iconoclasts, the church interior, or rather architecture with church-

1723 — J. Lukas von Hildebrandt completes the Upper Belvedere in Vienna 1725 — Birth of the Italian adventurer Giacomo Girolamo Casanova
1726 — Following his release from the Bastille prison, Voltaire, the leading philosopher of the Enlightenment, goes to England

24

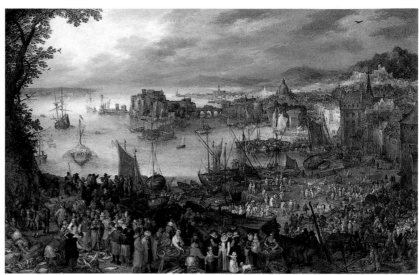

"It is true that one can find the entire chromatic scale in the few pictures he painted. But his combination of lemon yellow, pale blue and light grey is as characteristic of him as the harmonisation of black, white, grey and pink in velázquez."

Vincent van Gogh on Vermeer

es as a prime motif, became popular subjects in painting. This "concretization" of the sacred might be regarded as a kind of compensation, in much the same way as elements of the Eucharist began appearing in still lifes. The paintings of church interiors, in particular, do tell us a great deal both about their development and the way they were regarded. In the works of Emanuel de Witte (c. 1617–1692) or Gerard Houckgeest (c. 1600–1661), to name but two specialists in this genre, there are preachers and congregations to be seen, but it is far more common to find children playing in the outsized rooms, people strolling, or even dogs lifting a leg at a pillar – a motif that requires little interpretation. The actual subject matter of the picture is no longer the church interior itself, but the portrayal of light within a space that is perceived as space primarily because it is too large, unused and unaffected by the presence of people, its very existence as tranquil as an architectural still life. The objects in a room, especially objects bathed in light, and the room or space itself thus became a subject of Dutch painting. Each object – person, animal, room – is presented as though caught in a brief pause for thought. There are many variations in which elements of still life painting are combined with other objects. Thus the interiors of Jan Vermeer (1632–1675), for example, are like an extended space surrounding a still life.

Together with portraiture, the still life is a key genre in Netherlandish painting. In this field, too, there was considerable specialization and differences between individual schools. Haarlem concentrated on portraying banqueting tables laden with opulent dishes. Leiden focused more on vanitas still lifes full of books, jugs, tobacco pipes and writing implements. In The Hague, seafood predominated. What is more, there were considerable differences between Flemish and Dutch still lifes as well. In Antwerp, the work of Frans Snyders (1579–

1657) presents sumptuous still lifes which are invariably a theatrical staging of extremely diverse objects and precious items. If Flemish still life can be described as "extensive", Dutch still life may be called "intensive" in the sense that it draws its appeal from its concentration on only a few things. Even where the Haarlem "banquets" are based on the Flemish model, space and light are handled very differently indeed.

The landscape of the Low Countries and the sea, imagined memories of southern climes, Arcadian fields, landscape as a portrait of a certain place or an area and landscape as a projection of imagination did not become an independent genre until the Baroque era and, when it did, the Netherlands led the field. Dürer's watercolour landscapes had already helped to emancipate the genre to some extent prior to 1500. With Pieter Bruegel the Elder (c. 1525/30–1569), such elements as mood, atmosphere and individuality took on greater independence. There is something celestial in his portrayal of the months and seasons. In the Baroque landscapes between van Goyen, Jacob van Ruisdael and Hobbema, a new element comes to the fore which had previously been a mode of illustration. Aerial views had been known since the days of Leonardo da Vinci, and artists were also well aware of the fact that objects in the distance change not only in terms of linear perspective but also in terms of light and colour. Netherlandish landscape painting took distance, space and atmosphere – the interim zone between objects in which light develops its effects – and made this the subject matter of their painting. Void and distance thus become objects – a subject matter as calm as any part of a still life. This concretization of space and light is the hallmark of Netherlandish landscape painting. It is interesting to note that the horizon of land or sea is often very low, unlike that of the early landscape paintings with

1729 — The first celestial atlas catalogues 2866 stars on the basis of telescope observations by John Flamsteed
1730 — François Boucher returns to Paris from Rome 1736 — Construction of the Trevi fountain begins in Rome

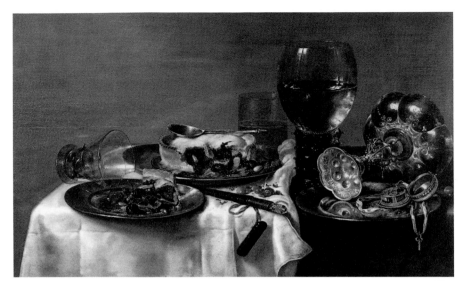

28

their sweeping and almost universal distances. From a bird's eye view, or at least from a raised viewpoint, a sense of distance is created by placing the centre of perspective and the horizon very low. In *Views of Haarlem with Bleaching Grounds* (Zurich, Kunsthaus) the spectator experiences the light through its effect on the objects, in the way the sun falls on the lenghts of cloth laid out on the ground – as trivial as they are solemn. A similar phenomenon may be observed in the work of Vermeer, where a woman stands at a window, contemplating her pearl necklace in the light. Simple light is transformed into a ceremonious event, in its penetration of the room and in the way it falls on objects. Yet for all the mutability and transience of light, it is not brief moments that are portrayed in such interiors and landscapes, but "heightened" moments in which everday occurrences becomes celebratory moments.

Nowhere is the specialization of Netherlandish painting so evident as it is in landscape painting. There was an Italianate form which adopted elements of Italian painting as well as southern and ancient motifs. Many of these Italianate landscape painters had studied in Italy, including Herman van Swanevelt (c. 1600–1655), Berchem and Jan Asselijn (1610–1652), and were profoundly influenced by Rosa and Lorrain. Then there were the Haarlem landscape painters who favoured low horizons and the sweeping expanses of the dykes and polders by the sea. Van Goyen initially painted in Haarlem, and Jan Porcellis (c. 1584–1632), Hercules Seghers (1589/90–c. 1633) and Salomon van Ruysdael (c. 1600/1603–1670) were members of the Haarlem Guild. Seascapes included calm and tranquil scenes with a slight swell in the evening light (Jan van de Capelle, c. 1624/25–1679) as well as the stormy sea with endangered or capsized ships, favoured in Antwerp, and there were also paintings of shipping fleets

(Willem van de Velde, 1633–1707), while the history painting of the fighting Dutch fleet barely played a role in the 17th century and lost its significance in much the same way as the battle painting.

In the Southern Netherlands, most notably under the influence of Rubens, a style of landscape painting developed which, for all its differences, bore many similarities with that of the Dutch school. This is evident, for example, in the work of Jan Siberechts (1627–c. 1700/1703) of Antwerp, who integrated Dutch elements into Flemish painting. Certain components which remained the preserve of individual specialists in Dutch painting can be found together in a single painting in the work of the Flemish artists: calm and sweeping plains are thus combined with bizarrely vibrant mountains, or the idyll of a river meandering through a shady forest with a sweeping view towards a distant horizon. Rubens' later work includes some of the finest landscape paintings in the history of European art. The wealth of nature is reflected in the colour spectrum, making Flemish rural life appear like some lost Arcadia, and the young men and women bringing in the harvest seem to hail from some strange metamorphosis of deities in disguise. The difference between Dutch and Flemish painting might be described, albeit with some exaggeration, as follows: in Dutch painting, we find beauty rendered in a concentration of the representational, whereas in Flemish painting the representation of the world appears to be a vehicle for poetic metaphor.

Genre painting, as it has come to be known (for lack of a better description), encompasses the entire circle of social themes: portrayals of scenes from everyday life, music-making, love, rakish living, tooth-pulling, the doctor's visit or the self-portrait of the artist in his studio. Needless to say, there were specialists for each individual type within the field of genre painting. Steen was regarded as a specialist

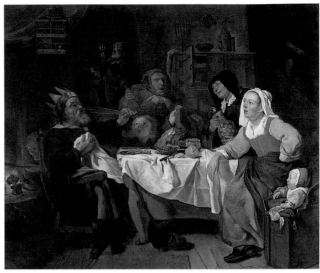

28. WILLEM CLAESZ. HEDA
<u>Still Life</u>
1631, Oil on panel, 54 x 82 cm
Dresden, Gemäldegalerie Alte Meister

29. GABRIEL METSU
<u>The King Drinks (The Beanfeast)</u>
c. 1650–1655, Oil on panel, 80.9 x 97.9 cm
Munich, Bayerische Staatsgemäldesammlungen,
Alte Pinakothek

of the wittily rendered "topsy-turvy world", involving moralizing or raucous scenes, while Gabriel Metsu (1629–1667) concentrated his efforts on minutely detailed portrayals of tranquil interiors. Brouwer and Adriaen van Ostade (1610–1685) made small-scale peasant genre paintings their speciality. Though such a list could easily be extended *ad infinitum*, to do so would risk lending weight to a misunderstanding of Netherlandish genre painting that has been prevalent since the 19th century. This misunderstanding has tended to arise when the paintings are regarded as anecdotal, as portrayals of specific situations or as illustrations of certain activities. Such an interpretation should be treated with caution in view of the fact that, even though a work by Brouwer or Ostade may show a momentary situation or brief activity, certain elements of the still life may also frequently be found. This is particularly evident in the genre paintings by Vermeer, in which several people are gathered in a beautiful interior, perhaps drinking or making music, but where it is also clear that this is not a portrayal of activity between protagonists, but of concentration on the material world with its glasses of wine, musical intruments etc.

Just as we can often find the symbols of vanitas behind a still life, so too can we find the iconography of the "five senses" behind the genre or moral painting. Initially, the five senses – touch, hearing, taste, sight and smell – were rendered in the form of personifications. A graphic series after Hendrick Goltzius (1558–1617), created around the end of the 16th or beginning of the 17th century, bears inscriptions warning against indulging the senses. In a painting by Ludovicus Finson (c. 1580–1617) the personifications are united in a single picture. Around a table there are women with musical instruments, and men fondling the women, tasting wine or smelling a rose. If Netherlandish genre painting can be traced back to such specific

types, we can no longer regard it as simply a portrayal of real life in the Netherlands. What we find here is not based on the depiction of a fleeting moment, but on rather more sophisticated visual formulae of enormous vitality, developed through longstanding tradition and, in the works of the Utrecht school in particular, heavily influenced by Caravaggio.

Utrecht played a particularly important role in mediating between Italy and the north. The city, having remained largely Catholic, still commissioned religious works and, what is more, had retained its contacts with Rome. The later exponents of the Utrecht school, Hendrick Terbrugghen (c. 1588–1629), Gerrit van Honthorst (1590–1656) and Dirck van Baburen (c. 1590/95–1624), all spent several years in Italy, where they also received commissions. Honthorst was employed by the Grand Duke of Tuscany and became known as "Gherardo delle Notti" – Gerard, the painter of night scenes. This nickname indicates an extremely important characteristic of the Utrecht painters. They had adopted Caravaggio's chiaroscuro, which they tended to apply in a more representational manner.

Whereas Caravaggio himself sought to create a contrast between his handling of light and the dark ground, Honthorst and Terbrugghe (who may well have known Caravaggio personally), use the technique to create a night scene in which artificial sources of light such as torches or candles illuminate part of the painting so that it stands out against the darkness. The possibilities of dramatic effects, the theatrical contrasts and surprises, as well as the pathos-laden modelling of the objects in chiaroscuro, came into fashion at the same time as Italian, Spanish and French painting. The Utrecht Caravaggisti and the Tenebrosi (from the Italian *tenebroso*, meaning dark or shadowy) were thus an international phenomenon. Without them, the

1742 — The *Großes vollständiges Universallexikon aller Wissenschaften und Künste*, the largest German language lexicon of the 18th century, is published in Leipzig 1745 — Madame de Pompadour becomes Louis XV's mistress and gains political influence

30

31

heightened chiaroscuro contrasts in the early works of Rembrandt would be unthinkable.

In Rembrandt's paintings of the 1630s, for example, the tension between the darkened pictorial space and the spot-like areas of illumination corresponds to the realism of expression and the portrayal of objects. The more "realistic" the objects become, the greater is the dramatic tension between unmotivated and sudden points of illumination in the dark pictorial space. This is true of more or less all Netherlandish painting: in the final phases of late Mannerism, it went through a phase of Caravaggesque chiaroscuro in which the concentrated intensity of Baroque painting emerged in response to the extensive elongations of Mannerism. Just as light emphasizes and delineates the key features of the painting by contrasting it with the darkness of the surrounding scene, so too does the painting seem to have shed the ballast of Mannerist improbability. In this context, some scholars have described Dutch painting as "concave", by which they mean that the essential objects are to be found together, as in the concave hollow of a dish.

One further phenomenon would also appear to be based on techniques of chiaroscuro in the manner of Caravaggio: light itself became the subject matter of the painting. Whereas earlier works featured artificial sources of light such as candles or lanterns, artists soon turned their attention to the portrayal of sunlight, in hazy atmospheres and in interiors lit by sunlight falling through a window. Even the works of Vermeer, who shows light lying on and even modelling objects, owe much to the influence of Caravaggesque genre painting.

In Dutch painting, the early phase of Caravaggesque painting gradually gave way to colority. This is strikingly obvious if we compare, say, the landscapes of Pieter Brueghel with those of van Ruisdael or van Goyen. Whereas Brueghel's landscapes are made up of colours juxtaposed with more or less equal emphasis, the Dutch artists of the Baroque era use similar tones bound together by non-colours. They seem to be inherent in shades of grey and brown, with a potential for colour that can only be awakened through the light.

In the work of Rembrandt during the 1640s, the contrasts that lend shape and substance to objects begin to dissolve, the spot illuminations and their shadows recede, and colour becomes less of a determining factor. The space he portrays is no longer a dark space from which the objects stand out through the handling of light, but has become a colourless background in which light and colour are potentially immanent. In this way, brown takes on a new role as an underlying value. At first a non-colour, it nevertheless seems to contain colours − red and yellow, sometimes green − which can be called up at will. What the 19th century admired so much in the work of the Dutch artists, particularly Rembrandt, as a "gallery tone", and regarded as a mysterious artistic sleight of hand, is not a brown coating applied over the original colority of the painting, but a tonal medium containing potentially vibrant colours. In landscape painting, the counterpart to Rembrandt's "gallery tone" can be found in the "tonal" period in which such artists as van Goyen, for example, reduced the range of colours in a coastal landscape to browns, olives and blues. Taken to an extreme, they can even be monochromatic brownish-green. These paintings may be described as "tonal" because their "tones" are subdued and reduced, yet nevertheless fully evident as tones.

The new Dutch painting also differs from its Mannerist forerunner in that it does not combine proximity and distance by forging some bold link, but by making the extremes of proximity and distance independent elements in their own right. Astonishing painterly methods

1745 — Maria Theresa of Austria becomes Holy Roman Empress **1749 — George Frederick Handel composes his *Fireworks Music***
1750 — In his *Discourse on Science and the Arts*, Jean-Jacques Rousseau describes the French philosophy of "back to nature"

30. PIETER JANSZ. SAENREDAM

<u>Church Interior in Utrecht</u>
1642, Oil on panel, 55.2 x 43.4 cm
Munich, Bayerische Staatsgemäldesammlungen,
Alte Pinakothek

31. JAN VAN GOYEN

<u>River Landscape</u>
1636, Oil on panel, 39.5 x 60 cm
Munich, Bayerische Staatsgemäldesammlungen,
Alte Pinakothek

32. JACOB VAN RUISDAEL

<u>Two Watermills</u>
c. 1650–1652, Oil on canvas, 87.3 x 111.5 cm
London, National Gallery

32

are used to address not only distance and infinity, but also extreme proximity. For Dutch painting also tends to dissolve the visual boundaries of the painting towards the foreground, towards the spectator, in the kind of illusionistic paintings known as *trompe l'œil*. The imitation transcends the bounds of the pictorial plane towards the spectator. The curtain – a device frequently found in the works of Vermeer and Rembrandt – also has an illusionistic effect. It appears to lie within the picture plane and yet already seems to form part of the real space where the spectator is standing. In this way, the transition from real space to pictorial space is camouflaged. *Hermann Bauer*

1750 — Start of the vogue for all things Chinese, and in particular porcelain, silk, lacquerware, goldfish etc.

тhe Entombment

Oil on canvas, 300 x 203 cm
Rome, Pinacoteca Vaticana

* 1573 Caravaggio (near Milan)
† 1610 Porto Ercole

Caravaggio was the son of a ducal architect. His early training was under a little-known pupil of Titian. In 1592 he went to Rome, where he earned his livelihood by painting run-of-the-mill pictures. His contact with Cesare d'Arpino, the most popular painter and art dealer in Rome at the turn of the century, brought recognition but no material independence. However, it was through the art business that Caravaggio met his first patron, Cardinal del Monte, who not only held out the possibility of working independently, but also secured for him his first public commission for the Contarelli Chapel in San Luigi dei Francesi. Here, Caravaggio developed his characteristic treatment of light, which shoots dramatically into the dark world of his pictures, creating an intensely sharp yet alien reality. From then on he was inundated by public commissions. Yet because of his violent temper he was constantly in trouble with the authorities. In 1606 he became embroiled in murder and had to flee, finding refuge on the estates of Prince Marzio Colonna, where he painted the Vienna *Madonna of the Rosary*. On his wanderings he paused at Naples, painting exclusively religious themes. In Malta he was put up by the Knights of St John and painted several portraits of the grand master, Alof de Wignacourt. In 1608 he was granted the title "Cavaliere d'Obbedienza". This artistically fertile Maltese period was again interrupted by imprisonment and renewed flight. Going through Syracuse and Messina, where some major late works came into being, Caravaggio went on to Palermo and from there again to Naples. Here the news of the Pope's pardon reached him and, on arriving at Porto Ercole by ship, he was again arrested but later released. By then the ship had sailed, including all he possessed. Struck down by a fever, he died without setting foot in Rome again.

Of all Caravaggio's paintings, *The Entombment* is probably the most monumental. A strictly symmetrical group is built up from the slab of stone that juts diagonally out of the background. The painting is from the altar of the Chiesa Nuova in Rome, which is dedicated to the Pietà. The enbalming of the corpse and the entombment are actually secondary to the grief of Mary, which is the focal point of the lamentation. Nothing distinguished Caravaggio's history paintings more strongly from the art of the Renaissance than his refusal to portray the human individual as sublime, beautiful and heroic. His figures are bowed, bent, cowering, reclining or stooped. The self-confident and the statuesque have been replaced by humility and subjection.

> "It is Rembrandt who finally discovers what Caravaggio so desperately sought: a lighting that wrests his humble figures from the night in order to assign them to eternity."
>
> André Malraux

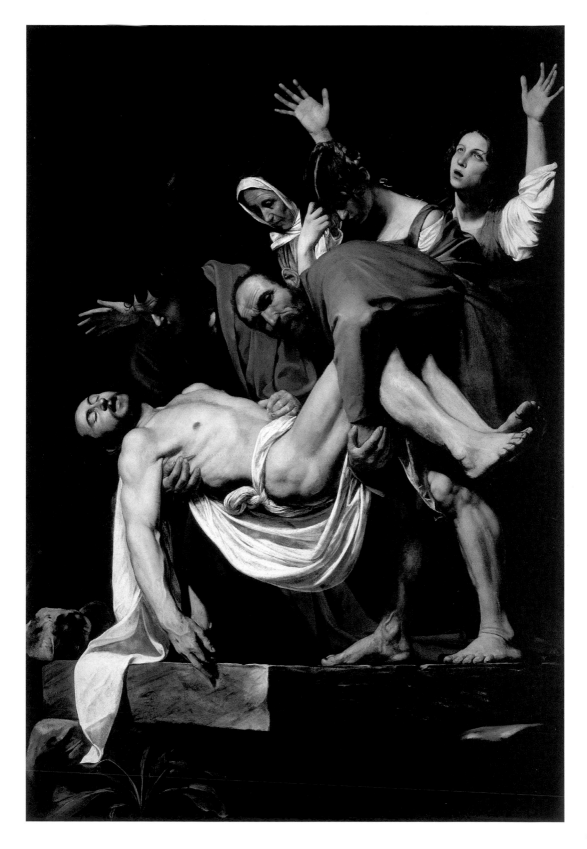

Triumph of Bacchus and Ariadne

Ceiling painting (detail)
Rome, Palazzo Farnese

"carracci brings together all that is good: raphael's gracious line, michelangelo's thorough anatomy, correggio's refined manner of painting, titian's colouring, and giulio romano and mantegna's powers of invention."

Gianlorenzo Bernini

* 1560 Bologna
† 1609 Rome

Annibale Carracci took as his starting point the Mannerist style in his early work (*Butcher's Shop*, Oxford, Christ Church Library Collections), developing it through his study of Correggio at Parma (1584/85) and the works of Titian and Veronese, to a sensual classicism enlivened by an inner unrest and true-to-life naturalness. He had already left the Accademia del Naturale, later called the "eclectic" school, in 1595, which he had founded in Bologna together with his cousin Lodovico and brother Agostino. In the 49 years of his life Annibale gained importance not only for his frescos, but also as a painter of Baroque altar pieces.

As the 16th century drew to a close, a certain weariness of the forms of late Mannerism, which dominated the entire European art scene by the second half of the century, was becoming evident. In this respect, the early Baroque in Italy may also be regarded as a conscious and critically motivated phase of reform in every field of art. A masterpiece of this reform movement was the huge cycle of paintings commissioned to decorate the Galleria Farnese in Rome, created under the auspices of Annibale Carracci, who was responsible for its planning and execution. The grand mythological programme representing the power of love by way of example of the Olympian gods went hand in hand with an aesthetic concept that was to be of fundamental importance for all subsequent Baroque fresco painting. Clearly evident in this major work is the goal underlying the academy founded by the three Carracci in Bolgna, namely to revive the canons

of classical art, and in particular the natural ideal once embodied by the art of the High Renaissance. Adopting an approach based on synthesis, Annibale Carracci created not a work of stale eclecticism, but a visual world of enormous vitality in which it was possible to develop a single programme – based on Ovid's *Metamorphoses* – over a vast area. At the same time, Carracci jettisoned the more esoteric elements of Mannerism in order to convey the heady eroticism and physicality of the myths with greater immediacy. In the bridal procession of Bacchus and Ariadne, which fills the central area of the ceiling, these qualities are fused into the most highly condensed composition of the Farnese Gallery.

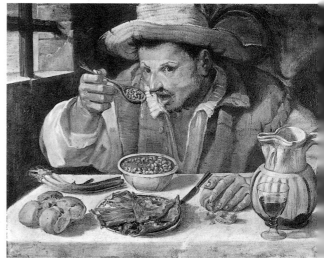

The Bean Eater, c. 1580–1590

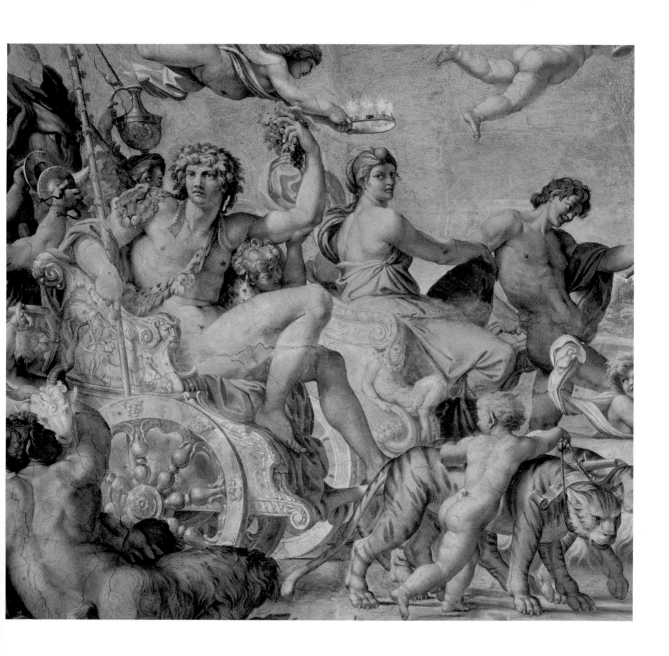

THE MASSACRE OF THE INNOCENTS

Oil on canvas, 268 x 170 cm
Bologna, Pinacoteca Nazionale

* 1575 Calvenzano
† 1642 Bologna

The son of a musician, Reni was also musically gifted, but began his training as a painter at the age of nine in the workshop of Calvaert, then at thirteen in that of the Carracci brothers. In 1598 he was already involved in the façade decoration of the Palazzo Pubblico in Bologna. He went to Rome with Albani in 1602; he returned to Bologna and again left for Rome in 1605, where he was to spend many years. His patron Cardinal Caffarelli-Borghese secured innumerable commissions for him, causing him to employ assistants. Later, he went in for mass production to pay for his passion for gambling. In 1622 he returned to Bologna and became the leader of the Bolognese school on the death of Lodovico Carracci. In early works, such as the *Coronation of the Virgin, with Saints*, Reni combined Mannerist and also northern elements with those of the Roman High Renaissance, that had been revived by the Carracci. The *Crucifixion of St Peter* (1603; Rome, Pinacoteca Vaticana) may be seen as an example of his Caravaggist period, which was followed by the development of a personal style around 1608 (Samson frescos, Vatican). His most celebrated work, *Aurora*, a ceiling fresco in the Palazzo Rospigliosi, 1612–1614, combines a clear palette and harmonious composition with masterly figure representation. His Madonna pictures, to which Reni owed his fame in his lifetime and until the 19th century, no longer appeal today with their grand and monumental perfection.

Though the historical significance of Caravaggio and his enormous influence on Baroque painting cannot be overlooked, we should not ignore the the fact that there was considerable resistance against the more extreme tendencies in his art, such as the loss of the heroic sphere, or the presentation of the everyday and the ordinary. His greatest rival, whose influence was to extend far beyond that of Caravaggio well into the 18th and 19th centuries, was undoubtedly the Bolognese artist Guido Reni. An early work such as *The Massacre of the Innocents* bears clear traces of his initial links with Caravaggio and, at the same time, already reveals the most important arguments against him.

Before a landscape bathed in light, but set with dark and heavy architecture, a group of eight adults and eight children (including the putti distributing the palm fronds of victory) has been skilfully arranged. The unusual vertical format, rarely used for this theme, and above all the symmetrical structure of figural counterparts indicate that Reni was particularly interested in a specific problem of composition: that of achieving a balance between centripedal and centrifugal movement while combining them in a static pictorial structure. Reni also seeks to achieve this equilibrium in his expression of effects and in the distribution of colour accents.

David, 1605

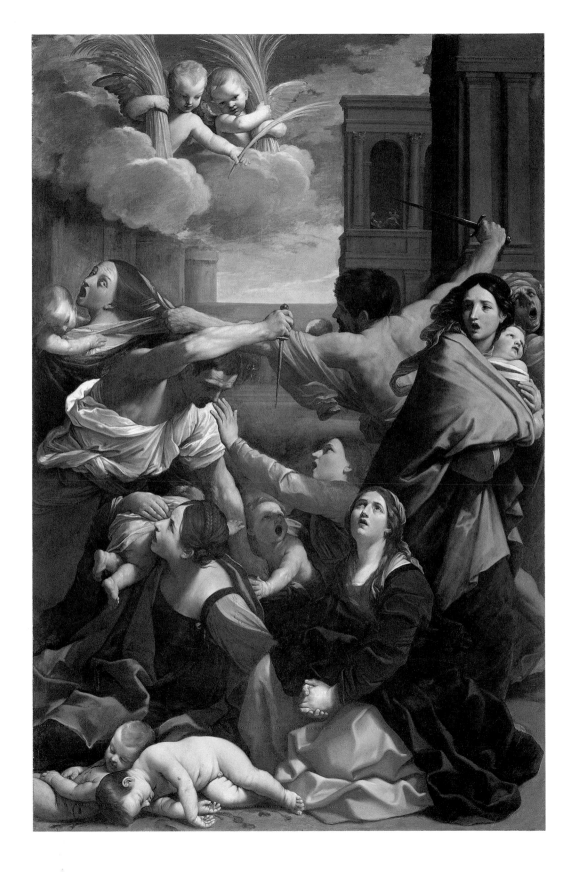

sacra Famiglia (The Holy Family)

Oil on canvas, 57 x 43 cm
Florence, Galleria Palatina

* 1578 Bologna
† 1660 Bologna

Although soon falling into oblivion after his death, Albani achieved considerable fame and prosperity during his lifetime. With Reni and Domenichino, he studied at the Carracci Academy in Bologna. He assisted in decorating the Aldobrandi lunettes, designed the apse of Santa Maria della Pace in Rome and worked at the court of Mantua in 1621/22. In 1625 he settled in Bologna for good. He owed his reputation as the "Anacreon of painting" to his landscapes with staffage figures. They were mostly mythological, gently balanced, set in an arcadian landscape. He was rediscovered in the 20th century because his manner of representing nature is reminiscent of Nicolas Poussin and Claude Lorrain.

Albani is a typical representative of the reform movement introduced by Carracci. As a student of the Bolognese artists and a colleague of Annibale who collaborated on the decoration of the Aldobrandini lunettes, he had developed a degree of confidence in his choice and application of stylistic means that allowed him not only to handle large wall areas, but also to create small and intimate devotional pictures. In his *Sacra Famiglia* or *Holy Family* Albani finds that characteristic blend of sovereign grace and delicacy that today's spectator may find slightly disturbing. Those of us who regard such emotional emphasis and charm with some suspicion tend to forget the specific tasks and needs these pictures were intended to fulfil in order to satisfy a highly educated and cultivated group of buyers. The usual setting for pictures on this theme was a niche in the bedroom of a patrician house or palace intended for devotional purposes. This function also explains some of the typical traits of such a picture: the intimacy of a family gathering, framed by fragments of great architecture, the gestures of devotion of the two angels and the meditative attitude of the elderly Joseph – all signals with which the contemporary spectator would have been able to identify clearly.

> **"Books are the true means of acquiring talent, for if one does not read one remains ignorant, and ignorance can never produce true painters."**
>
> Francesco Albani

The Rape of Europa, c. 1639

тhe Return of the рrodigal son

Oil on canvas, 106.5 x 143.5 cm
Vienna, Kunsthistorisches Museum

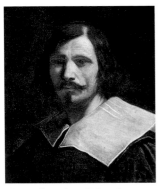

* 1591 Cento (near Bologna)
† 1666 Bologna

"Il Guercino" (the squint-eyed) was a nickname given because of the squint in his right eye. He was the leading painter of the Bolognese school alongside Reni. He was taught by Paolo Zagnoni in Bologna and was influenced by the work of Lodovico Carracci. Between 1615 and 1617 he painted interior decorations in Cento and produced religious works and landscapes. At the commission of Cardinal Alessandro Ludovisi, later Pope Gregory XV, he painted the frescos in the oratorio of San Rocco, Bologna. His visit to Venice in 1618, where he met Palma il Vecchio, served to develop his style further (*Et in Arcadia ego*, Rome, Galleria Nazionale d'Arte Antica; *Martyrdom of St Paul*, Modena, Galleria Estense). In subsequent years his pictures became increasingly lively and dramatic, primarily achieved by the contrast of light and shade. In 1621 he followed a call to Rome by Pope Gregory XV, for whom he worked until his death. Here he painted his best-known work, the *Aurora*, on a ceiling of the Villa Ludovisi. He explored his Roman experience when he returned to his home town, drawing in particular on Domenichino and Reni (*The Virgin with St Bruno*, Ferrara, Pinacoteca Nazionale; *Ecstasy of St Francis*, Dresden, Gemäldegalerie). There was now more pathos, and his freshness was replaced by an idealised Classicism; light and colour became cooler. On Reni's death in 1642 Guercino became the head of the Bolognese school. His attempts at regaining his former lively style were, however, not always successful.

This work is from Guercino's early period, when he was beginning to achieve some initial fame and was already familiar with the two main trends of early Italian Baroque, Caravaggism and the Bolognese reform of the Annibale Carracci school. His decision to use the approach of Caravaggio may have something to do with the choice of subject matter, contrasting the humility of human existence and the possibilities of costume as disguise – a concept formulated by Caravaggio in his paintings for San Luigi and frequently taken up by his followers. Guercino does not portray the return of the prodigal son as a scene of recognition or joy, choosing instead to depict a more tranquil motif from the biblical parable – the moment when he is given fine robes to wear. On the left in the painting, the young man has stood up and is removing the rags of the swineherd, while an old man, presumably his father, places a hand on his shoulder and takes a clean shirt from the other, foppishly dressed young man who is holding new clothes over his outstretched arm and new shoes in his hand. By using light and shade to divide the group, Guercino lends a singular autonomy to the dynamics of the outstretched and grasping hands, thereby intensifying the narrative in a most unusual way.

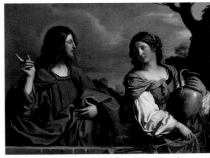

Christ and the Samaritan Woman, c. 1640/41

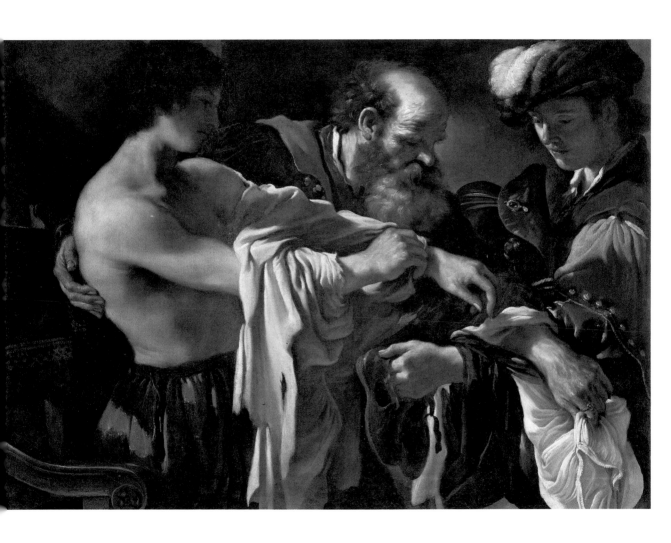

The Fall of the Rebel Angels

Oil on canvas, 419 x 283 cm
Vienna, Kunsthistorisches Museum

* 1634 Naples
† 1705 Naples

Giordano, who received instruction from his father Antonio and from Ribera, ranks as the first Baroque "virtuoso" in the 18th-century sense. The number of his oil paintings is estimated to be over 5000, which brought him the nickname "fa presto" (do it quickly). He also had the ability to copy any style. While he was greatly influenced by Ribera in his early years, he later developed a style which showed his familiarity with Rubens, van Dyck, Cortona, and most of all the great Venetian painters such as Titian and Veronese, whom he had discovered on a visit to the northern parts of Italy in the early 1650s. In 1654, having returned to his home town, he received a commission for two paintings for the choir of San Pietro ad Aram, and he produced the *Madonna of the Rosary* (Naples, Galleria Nazionale), the *Ecstasy of St Alexius* (Arco, Chiesa del Purgatorio) and *Tarquin and Lucretia* (Naples, Galleria Nazionale). On a second visit to Venice in 1667 he painted there the *Ascension of the Virgin* for Santa Maria della Salute, which in its generous conception is reminiscent of Cortona. Giordano's fame was established with his two large St Benedict cycles for Monte Cassino (destroyed 1943) and San Gregorio Armeno (Naples). From 1679–1682 he worked spasmodically on the ceiling of the gallery in the Palazzo Medici-Riccardi in Florence. Charles II called him to the Spanish court in 1692, and in the following ten years Giordano produced major works, such as the frescos in the San Lorenzo church at Escorial and the Bible scenes in the Buen Retiro palace near Madrid. He returned via Genoa, Florence and Rome to Naples in 1702. One of his last important works was the fresco in the cupola of Tesoro Certosa di San Martino.

The fall of the rebel angels is the greatest single theme of the Counter-Reformation. It is a subject that allowed a Church in conflict to present its propaganda in the form of its struggle against all forms of heresy. At the same time, the theme of the struggling angel also symbolized the triumph of light over the rebellion of the powers of darkness – giving the painter an opportunity to create a chiaroscuro charged with meaning, in which heaven and hell, the incense of the blessed and the brimstone of the damned are contrasted in an extremely confined space, creating an arc of tension within which the knight-like angel spreads his broad wings and wields his sword in a sweeping gesture of victory. Giordano sets the scene with relatively few figures compared to, say, Rubens' *Great Last Judgement*. Against a background of deep golden light, the archangel balances with an almost balletic movement on the heavy breast of Lucifer, entangled amidst a group of his servants, his angular and batlike wings cutting through the hazy sfumato of the hellfire. What appears at first glance to be so dramatic is not in fact the depiction of a struggle as such. Michael is not attacking the figures from hell with his sword, but is holding it aloft like a sign, as though his mere appearance were enough to cast Satan and his followers into eternal damnation.

The Triumph of Galatea, c. 1682

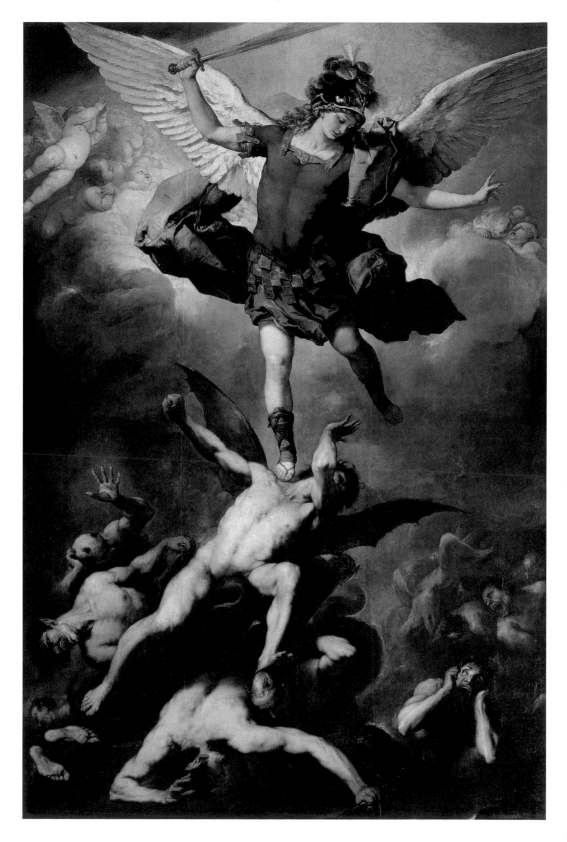

Hagar in the wilderness

Oil on canvas, 138 x 159 cm
Paris, Musée National du Louvre

* 1582 Terenzo (near Parma)
† 1647 Rome

As the pupil of Agostino Carracci, Lanfranco worked from 1600 to 1602 on the decoration of the Palazzo del Giardino in Parma. A short time after his master's death he was mentioned in Rome in the circle surrounding Annibale Carracci. In 1605, while in Rome, he decorated the Camerino degli Eremiti in the Palazzo Farnese (destroyed). Around 1610 he returned briefly to his home town, painting altarpieces for churches in Parma and Piacenza. Again in Rome, he carried out the two works which were to make him famous: the ceiling in the Loggia in the Casino Borghese with its extreme foreshortenings (*Council of the Gods*) and the fresco in the cupola with the *Assumption of the Virgin* for Sant' Andrea della Valle. These were to serve as an example to Pozzo and Baciccio with their characteristic powerfulness and monumental grandeur. In 1633/34 Giovanni Lanfranco made his way to Naples, where he carried out a number of large commissions, including the cupola of Gesù Nuovo and the frescos in Santi Apostoli, where he concentrated on achieving dramatic vividness rather than careful execution.

Sarah, Abraham's childless wife, brought her Egyptian maid Hagar to him so that he would produce an heir with her. However, when she herself bore Isaac, she demanded of her husband: "Cast out this bondwoman and her son: for the son of this bondwoman shall not be heir with my son, even with Isaac." (Genesis 21:10) Hagar and Ismael wandered in the wilderness, dying of thirst. Yet God heard the lamentations of the mother and sent her an angel who showed her the way to a spring and prophesied that her son would be the founder of a great nation. In the painting, Hagar, who has been crying, is just lifting her head to look up at the angel in astonishment; her child, half hidden behind her shoulder, is also looking up incredulously at the kindly angel who has taken Hagar by the arm and is showing her the way to the water. It is the handling of colour, in particular, that highlights the unexpected aspect of the occurrence so clearly: against the gloomy brown of the wasteland, the sumptuous red and midnight-blue of Hagar's robes radiate like a lamentation of pathos. Her pale, exhausted face is turned towards the shining figure of the angel that seems to have brought light with it. Light bathes the figure, and radiates from the angel towards Hagar, rising in a pale cloud behind the angel and enflaming the orange of his hair and robe.

> "His art upholds the principles and training of the carracci school and follows correggio in its concept and organization, whereby it is decisive in its execution instead of embroidered and blurred. He succeeded in laying down large areas of colour designed to be seen from a distance, and as he himself once said, the air did the painting for him."
>
> Giovanni Paolo Bellori on Lanfranco, 1672

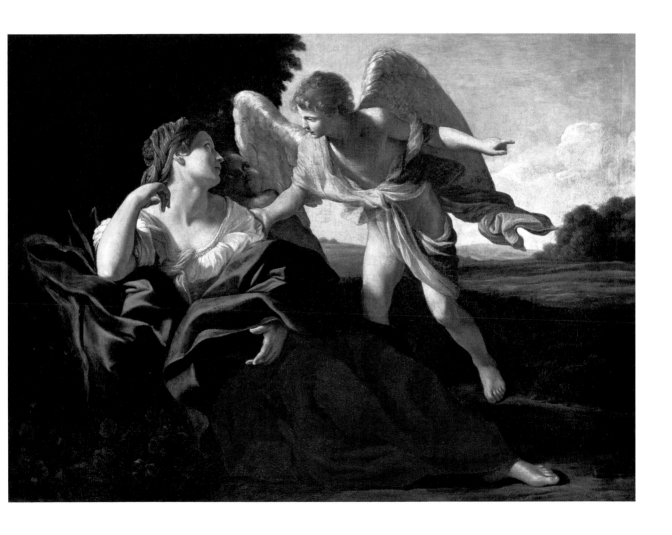

тнe тribute мoney

Oil on canvas, 193 x 143 cm
Milan, Pinacoteca di Brera

* 1613 Taverna (Calabria)
† 1699 Valletta (Malta)

Preti joined his brother in Rome in 1630. He probably studied in Modena, Parma, Bologna and Venice until 1641, when he returned to Rome to become a member of the Maltese Order. Initially influenced by the Roman High Baroque, including Lanfranco and Cortona (c. 1640, *Alms-Giving of St Charles Borromeo* for San Carlo ai Cartinari), he developed a vigorous style of his own which reflected the influence of Guercino combined with a Venetian treatment of colour, as shown in his frescos in Sant' Andrea della Valle (1651) and San Biago (1653–1656, Modena). Between 1656 and 1659 Preti produced votive pictures invoking protection against the plague in Naples, using sombre colours which show his great skill at rendering the human figure. *Absalom's Feast* (before 1660, Naples, Galleria Nazionale) and *Belshazzar's Feast* (before 1660, also Naples) typify Preti's complicated method of composition and his startling light effects. Preti spent his last years as a Knight Hospitaller in Malta where he achieved a most touching depiction of human deeds and sufferings with his *Scenes from the Life of St John the Baptist* for San Giovanni (Valletta).

Preti's biographer Dominici reports that *The Tribute Money* was executed in Malta, where the painter had travelled in 1660 as a Knight of Malta in order to work on the decoration of the cathedral of San Giovanni in Valletta. The painting is of particular interest in view of Preti's encounter with the works of Caravaggio, who had executed some important paintings in Malta after 1607. The theme treated here is the biblical tale culminating in Christ's fateful words: "Render therefore unto Caesar the things which are Caesar's; and unto God the things that are God's." (St Matthew, 22:21) In the dark brown tones of the painting, we can barely make out the six figures half illuminated by a light from some indiscernible source. The tax collector pauses in his writing as Peter hands him the coin. Only this pause indicates the miracle that has just occurred: Peter found the coin in a fish he had caught at the command of Christ (St Matthew 17:24). The turban of a man, a hand holding a pen, another holding a coin, a face in profile with a deeply lined forehead, turned towards another face of which we can recognize only the temple and the nose, a bald head, a little red fabric and the heavy folds of a rough brown cloth are the scattered but not unconnected fragments from which our gaze wanders to and fro, reconstructing the narrative.

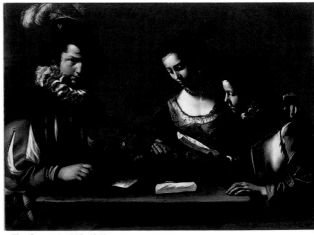

The Concert, 1630–1640

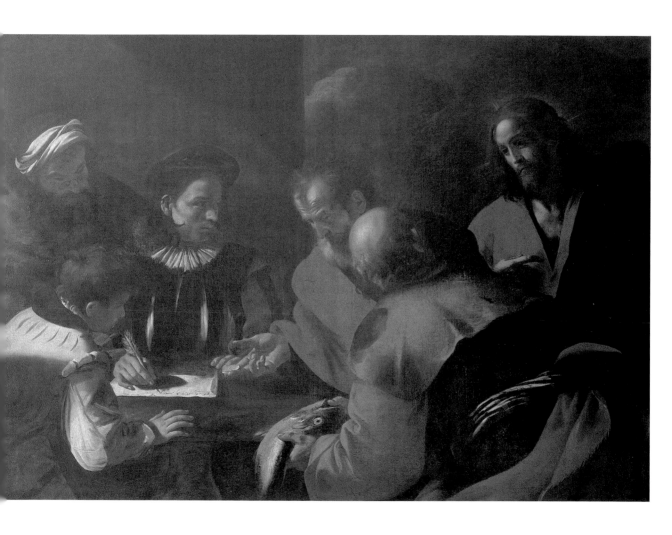

saturn, conquered by amor, venus and hope

Oil on canvas, 187 x 142 cm
Bourges, Musée du Berry

* 1590 Paris
† 1649 Paris

Vouet received only basic training from his father, a sign painter, but his talent developed rapidly; he is said to have been called to England at the age of fourteen to paint portraits. After visiting Constantinople and Venice, he came to Rome, where he became influenced by Caravaggism in the manner of Valentin. Reni's monumentality, the classical serenity of Domenichino's work and the ideas of Lanfranco and Guercino were also to have a lasting effect. In Genoa, where he met Strozzi, he produced one of his major works, the *Crucifixion* for San Ambrogio (1622). Louis XIII recalled him as "peintre du Roi" (1627) to France, where Vouet – always intent on furthering his career and never turning down a commission – produced works of great beauty and loftiness. Apart from painting altarpieces and portraits he also designed tapestries in his richly decorative style. He worked in the royal residence St Germain, the Palais du Luxembourg, Fontainebleau and the Louvre. His most important paintings include *Lot and his Daughters* (1633; Strasbourg, Musée des Beaux-Arts) and the *Allegory of the Victor* (1630; Paris, Musée National du Louvre). Many of the great decorative painters of the age were trained in his studio, including Le Brun, Mignard and Le Sueur.

Vouet had spent 15 years in Italy when Louis XIII and Cardinal Richelieu called him back to France to make him the artistic representative of their ideas, ideals and ideology. What made Vouet seem the right man for the job was not only his virtuoso painterly skills, but also his preference for large-scale yet beautifully balanced composition. In addition to religious themes, he also favoured allegorical depictions. Saturn as an old man, with his attribute, the scythe, in his hand, has fallen to the ground – he embodies Time. A young woman is pulling hard at one of his wings and the anchor at her feet indicates that she represents Hope. Beside her, a beautiful woman with a bare breast is tugging at his grey hair – she represents Truth. Above this group, in an iridescent robe, floats Fama, the figure of fame, who announces her presence with a trumpet. She has placed her arm around a figure whose hair is blowing forwards – the traditional attribute of Occasio, the fortunate occasion – with the insignia of power and wealth in her hand, which are also the attributes of Fortuna, the allegory of luck or good fortune. The luminous colours, the dramatic and yet masterly movement, are equivalents of the affirmative content of the allegory.

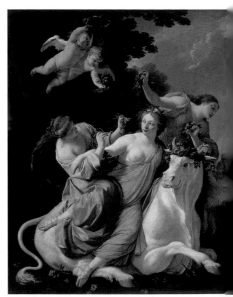

The Rape of Europa, c. 1640

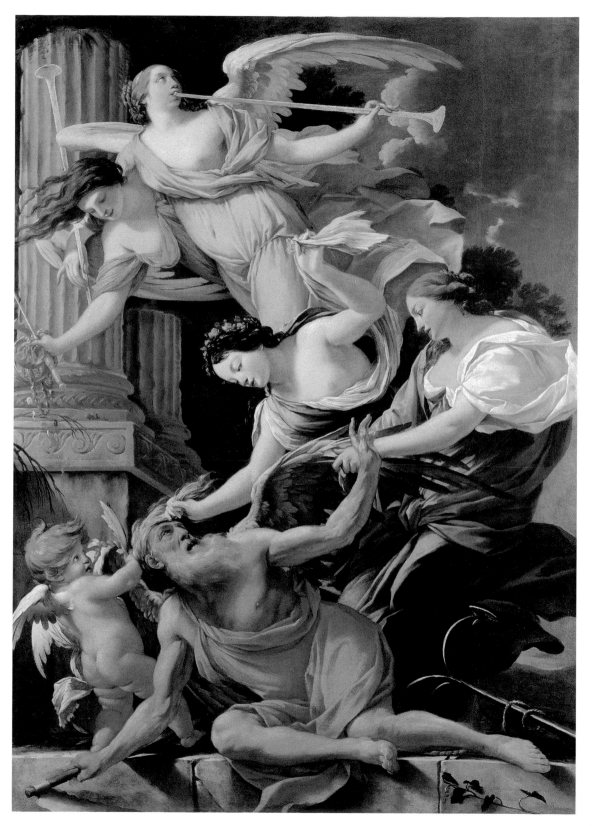

st sebastian Attended by st irene

Oil on canvas, 160 x 129 cm
Berlin, Staatliche Museen zu Berlin – Preußischer Kulturbesitz, Gemäldegalerie

Even in his lifetime La Tour must have been one of the most admired painters. He was ennobled, appointed "peintre du Roi", lived a luxurious life, had powerful patrons and so was able to charge enormous fees (such as for his *Peter Denying Christ*, 1650; Nantes, Musée des Beaux-Arts). This is especially surprising as he never left his home ground, except for a brief visit to Paris and a still disputed journey to Rome, and yet he produced up-to-date work without subordinating himself to modish tendencies. He soon fell into oblivion after his death, until the revival of his work in the 1920s when artists of the New Objectivity (Neue Sachlichkeit) mistakenly thought they had discovered in him an artistic predecessor of their own concepts. Only about twenty of his works survive, and these can be divided into his early stylised "day pieces" and the later "night pieces". But both attribution (he only rarely signed his work) and chronological order must remain questionable.

Unlike the Utrecht Caravaggisti, La Tour, who was probably introduced to Saraceni, Caravaggio or Gentileschi by his colleague Leclerc, gave less and less attention to accurate detail. His strange lighting effects, particularly in his late work, do not create blurred forms but instead sharp contours. His figures, even when only barely and in part illuminated, have an extraordinary plasticity.

In a work like the *The Card-Sharp with the Ace of Diamonds* (c. 1620–1640) the figures seem to embody an inscrutability which is further enhanced by the enamel-like, opaque painting technique.

In the 17th century, St Sebastian was one of the most important of all patron saints. Prayers were offered to him seeking protection against disease, especially the plague, which had affected the region of Lorraine particularly severely.

In reference to the medieval legend in which the widow Irene takes pity upon the martyr, who having been shot by arrows has been left for dead, we clearly see the expectations of care and attendance demanded of this saint. La Tour has painted a night scene illuminated by the torch Irene is holding. Grief, empathy and a range of light that runs from dazzling brilliance to deepest darkness all add up to a moving and meditative comment on charitable kindness.

"No painter, not even Rembrandt, suggests this vast and mysterious silence: La Tour is the only interpreter of the serene part of darkness."

André Malraux, 1951

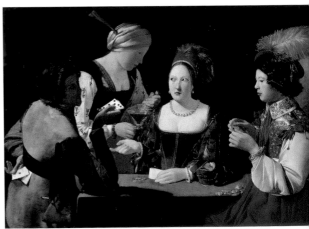

The Card-Sharp with the Ace of Diamonds, c. 1620–1640

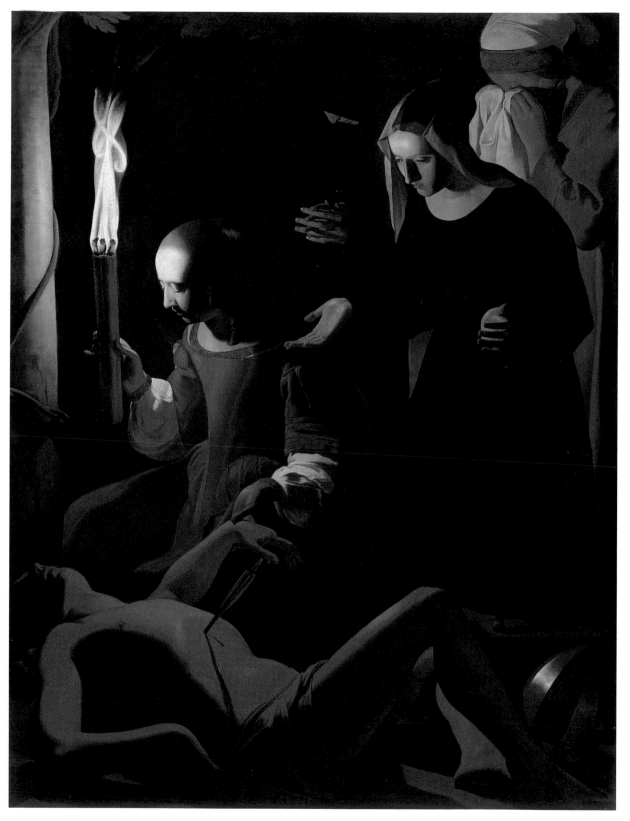

The Concert

Oil on canvas, 173 x 214 cm
Paris, Musée National du Louvre

As the most important representative of the French Caravaggists, Valentin de Boulogne came to Rome in 1612, where he was introduced to Caravaggio's work by Simon Vouet and Bartolomeo Manfredi. Valentin subsequently developed geometrical rules to deal with chiaroscuro, working out a system for light and shade effects. In Rome he belonged to a group of Scandinavian and German artists who called themselves "Bentvögel" and had chosen the motto "Bacco, Tabacco e Venere" (To Bacchus, tobacco and Venus). Through this group he came into contact with thieves, drunks, prostitutes, receivers of stolen goods and other members of an underworld which he vividly portrayed.

Apart from scenes of popular and soldiering life (*Disputing Card-Players*, Tours, Musée des Beaux-Arts; *Musicians and Soldiers*, Strasbourg, Musée des Beaux-Arts), he also produced religious works, preferably scenes from the Old Testament (*Judgment of Solomon*, Paris, Musée National du Louvre; *Judith and Holofernes*, Valletta, Museo Nazionale).

Valentin gave himself the epithet "Innamorato" – the enamoured. In Rome, he led a life his biographers found despicable. He associated with gamblers, whores, drunkards and, according to Sandrart, favoured the company of Dutch and Flemish artists. Valentin de Boulogne is of interest not only for his turbulent biography, but also as one of the most remarkable of the Caravaggisti. In a genre scene such as *The Concert* he proves his individuality as a follower of Caravaggio, by interpreting the latter's pictorial approach in a completely new way. On the other hand, Valentin is of only indirect significance for French painting.

A group of musicians with guitar, violin, mandolin and music score is grouped around a block of stone on which we can see an antique relief. In their midst is a half-grown child, while drinkers can be seen in front of and behind the stone. Formally, Valentin employs the chiaroscuro technique "invented" by Caravaggio, highlighting faces, a leg, feathers or a silken sleeve. Yet here, the darkness takes on an ambivalent depth: its gloominess casts shadows on the facial traits, filling them with a terrible sadness (none of the figures is laughing or even smiling). At the same time, it is the soil or germ from which all colour, the source of all life, springs.

> **"But he painted everything with thoroughly good judgement and left many magnificent works of art."**
>
> Joachim von Sandrart, 1675

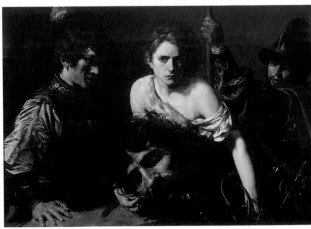

David with the Head of Goliath and Two Soldiers, c. 1620–1622

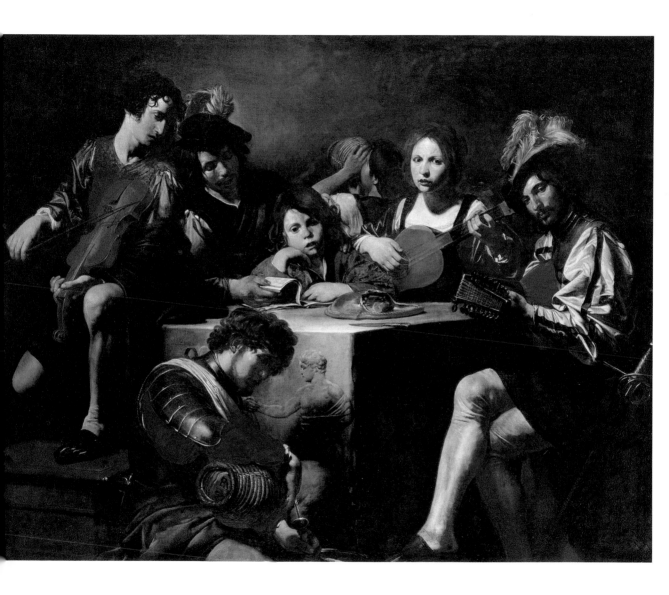

st cecilia

Oil on canvas, 118 x 88 cm
Madrid, Museo del Prado

* c. 1593/94 Villers-en-Vexin (Eure)
† 1665 Rome

The son of an impoverished family, Poussin received some early training from the painter Varin, who was travelling through his town. More thorough training followed in Paris, 1612–1624, as assistant to Champaigne and pupil of the Mannerist Lallemand, reinforced by independent study of predominantly Italian art in the Royal Collections. After several unsuccessful attempts, he finally went to Rome in 1624 with his patron and supporter Marino. The latter was a celebrated poet who introduced Poussin to ancient mythology and Ovid's works. Marino wrote an epic entitled *Adone* (1623) which was illustrated by Poussin. In Rome he worked for some time with Domenichino and developed his own style by exploring and perfecting Annibale Carracci's ideas on classical landscape painting. Already in his thirties, his palette became lighter and he showed a tendency to poetical and idealised representation of subjects from antiquity and the Bible (*The Inspiration of the Epic Poet*, 1630; Paris, Musée du Louvre and *Martyrdom of St Erasmus*, 1629; Rome, Musei Vaticani). His knowledge of the literary and pictorial traditions of antiquity and of the Renaissance, and his contact with contemporary intellectuals, plus his knowledge of history, all combined to turn Poussin into the prototype of a classical painter. With his Arcadian yearnings, his idealisation of friendship and manly virtues, and his predilection for sentimental resignation, he set a course for the moral and doctrinal tendencies of future generations of painters. During a brief stay in Paris, 1640–1642, he painted the Hercules scenes for the Louvre at the invitation of Richelieu and Louis XIII. Finding the artistic climate unfavourable, he returned to Rome and friends such as Dughet and Lorrain, and never left the city again.

The iconography of St Cecilia did not always depict the martyr as a musician. Raphael, for example, portrayed her listening enthralled to the sounds of celestial harmonies in such transports of delight that the instruments of earthly music fell from her hands. Poussin's interpretation, on the other hand, shows her playing music herself. Against a background of landscape and classical architecture, a putto draws a red drape to the side above the saint, creating the backdrop for an intimate concert. St Cecilia is playing on a keyboard instrument, accompanied by two singing angels who are standing before a column. In this way, Poussin has created a synthesis between the earthly musicianship of the saint and the strains of celestial music. Through the involvement of the angels, the earthly sounds are transformed into celestial harmony, beyond the hearing of profane ears, but visualized in the full-toned chord created by the cardinal trio of red, yellow and blue, which is played in every possible modulation from brightly illuminated planes to areas of darkness.

Moses Trampling on Pharaoh's Crown, 1645

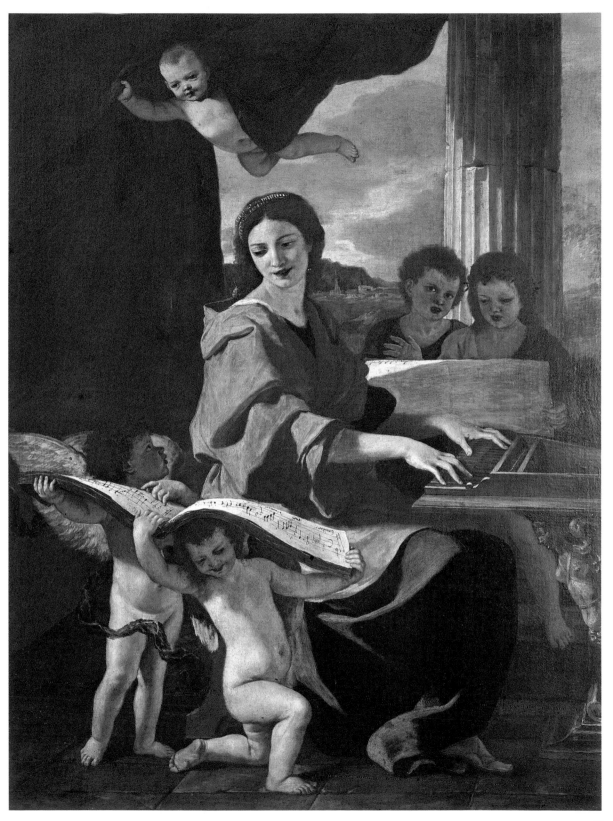

seaport at sunrise

Oil on canvas, 72 x 96 cm
Munich, Bayerische Staatsgemäldesammlungen, Alte Pinakothek

==

* 1600 Chamage (Lorraine)
† 1682 Rome

At the age of fourteen Lorrain came to Rome and, while working in artists' studios, came to the notice of Agostino Tassi, the landscape painter, who gave him lessons. Except for a period in Naples (1619–1624) and in his home country (1625–1627), he always remained in Rome. There he painted frescos of landscapes in the Palazzo Crescenzi and Palazzo Muti. He became a member of the Accademia di San Luca in 1634, and three years later was regarded as the leading landscape painter in Rome. He attracted the attention of the leading nobility and church dignitaries. Amongst others, the King of Spain commissioned seven religious paintings for his palace Buen Retiro. However, all his life his speciality remained the landscape in various forms, presenting it as veduta, as mythological scene and as a stage for stories from the Old Testament. His figure representation, influenced by the multi-figured type of small paintings known as *bambocciate*, was not very adept and often not carried out by himself. His landscapes, unlike those of Poussin, are characteristic in their relaxed, peaceful air, and painted in a large range of muted tones. With their bright atmosphere and their use of antique architecture as stage scenery, they set an example for classical landscape painting in the 18th and 19th centuries.

The great "inner" theme of 17th century painting is light. Illumination from some invisible source is contrasted with all-powerful darkness – in the work of Caravaggio, as the living light of a candle whose pale white flame permeates every nuance of shadow; in the work of Georges de La Tour; or as a view of the sun – boldly attempted for the first time by Claude Lorrain – shimmering through the fragile veil of the morning haze and dissolving the wide horizon of the sea with distant sails, landscapes with mountains, cities and towers. This light seems to reach the spectator from a world of the imagination rather than reality. The port with its Roman triumphal arch and crumbling defence walls may well be the setting for a scene from everday life in ancient times. Yet what we see here is not a reconstruction of classical antiquity. The ancient buildings are overgrown by bushes and grass; antiquity is merely an image, a ruin recalling a timeless world in which a transfiguring sun casts a morning light without shadow. Just as it is impossible to pinpoint the century in which the people of a Claude Lorrain painting live, so too is it impossible to name the countries where his landscapes might be found. Like no other artist before him, Lorrain made poetic reality the subject of his painting. In the painting *Seaport at Sunrise* Claude Lorrain shows bales of goods being transported between a cargo boat and the nearby shore using small boats. We cannot even tell for sure whether the goods are being transported towards the cargo boat or away from it. The labourers, the conversation on the shore and the group by the triumphal arch are mere staffage, little more than attributes of the landscape. This is not a scene of contemporary or ancient poetry, and the great classical ruins are not peopled by figures from mythology. In his own way, Claude Lorrain contributed towards genre painting and the preference of his epoch for portrayals of ordinary people. One might describe this transposition of everyday life into the past as *genre historié* – in much the same way that we use the term *portrait historié* to describe the technique, so popular in the Netherlands, of depicting living personalities as biblical or mythological figures.

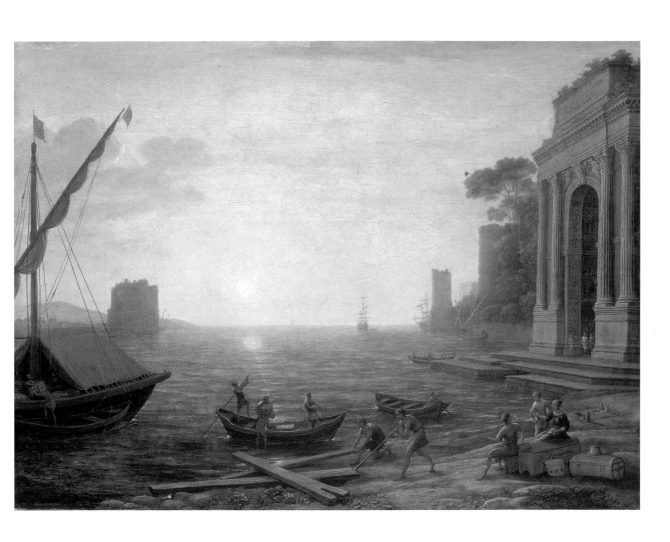

The Martyrdom of St John the Evangelist at the Porta Latina

Oil on canvas, 282 x 224 cm
Paris, Saint-Nicolas du Chardonnet

* 1619 Paris
† 1690 Paris

Having been the pupil of Perrier and Vouet, Le Brun was appointed "peintre du Roi" at the age of eighteen and received his first commissions from Cardinal Richelieu in 1640. Two years later he went with Poussin to Rome, where he studied and copied the works of Reni, the Carraccis, Raphael and Cortona. After returning to Paris in 1646 he soon developed his own style and was commissioned to decorate various great houses (Hôtel Lambert, Hôtel Nouveau), became co-founder of the Académie Royale in 1648 and there held the first of his famous "leçons" in the same year. His contact in 1657 with the government minister Fouquet resulted in the commission for the design of decorations in the Vaux palace (ceiling and wall frescos, 1658) and his appointment as director of the Gobelins manufactory. His introduction at court by Mazarin in 1660 brought him many commissions and the appointment as "first court painter" (1662). As the virtual dictator of the arts, Le Brun also designed furniture of massive silver, triumphal arches, fireworks and catafalques. Twenty years later he worked with his assistants on the decorations of the Small Gallery in the Louvre, designed decorations for Versailles, where he also decorated the Great Staircase (1674–1678, destroyed), and decorated Colbert's Sceaux palace (destroyed) and Marly (destroyed).

The martyrdom of John the Evangelist occupies a special position within the lives – and deaths – of the disciples of Christ. According to legend, John was arrested under Trajan in Rome at the Porta Latina and thrown into a vat of burning oil, but survived unhurt and was even rejuvenated. Although he later died a natural death, he was accorded the rank of martyr. Le Brun has chosen to portray the dramatic moment at which he is lifted into the boiling, steaming vat. Menacing idols and horseback soldiers bearing the symbols of imperial power flank the scene. Yet just as his executors are making their final preparations and fanning the flames, the doomed man receives the divine message of martyrdom, with laurel wreaths and flowers. The visible triumph of faith at the moment of extreme physical danger is the subject of all portrayals of martyrdom, but only high Baroque painting found formulations capable of balancing the spiritual rapture of a saint against manifestations of physical brutality.

Chancellor Séguier at the Entry of Louis XIV into Paris in 1660, 1660

Portrait of Louis XIV

Oil on canvas, 279 x 190 cm
Paris, Musée National du Louvre

* 1659 Perpignan
† 1743 Paris

Rigaud's surviving business records reveal that he had an extensive workshop and employed speciality painters for flower decorations, textiles and background battle scenes and landscapes. After his early training in Montpellier and Lyon, Rigaud went to Paris in 1681, where already in 1682 he aroused Le Brun's interest with his historical painting *Cain building the City of Enoch*. Le Brun urged him to take up portrait painting, and Rigaud soon became popular, and also known in court circles, where his van Dyck-inspired manner met with approval under the absolutist monarchy of Louis XIV. Despite the fact that he used assistants, Rigaud proved to be an acute reader of character, as is evident in his portraits of *King Philip V* (1701; Madrid, Prado) and that of *Elisabeth Charlotte, Duchess of Orléans* (1713; Brunswick, Herzog-Anton-Ulrich-Museum). In his famous portraits of the Sun King, however, he showed his mastery as a colourist and ability to satisfy ceremonial demands in pose and expression.

This famous portrait is regarded as the very epitome of the absolutist ruler portrait. Yet it represents more than just power, pomp and circumstance. The sumptuous red and gold drapery is not only a motif of dignity, but also creates a framework that echoes the drapes of the ornate, ermine-lined robe. The blue velvet brocade ornamented with the golden fleurs-de-lis of the house of Bourbon is repeated in the upholstery of the chair, the cushion and the cloth draped over the table below it: the king quite clearly "sets the tone". A monumental marble column on a high plinth is draped in such a way that it does not detract from the height of the figure. Louis is presented in an elegantly angled pose, situated well above the standpoint of the spectator to whom he seems to turn his attention graciously, but without reducing the stability of his stance.

Rigaud's consummate mastery of portraiture is particularly evident in the way he depicts the king's facial expression: his distanced unapproachability are not founded in Neoclassicist idealization, but in the candour of an ageing, impenetrable physiognomy. The lips are closed decisively and with a hint of irony, the eyes have a harsh, dark sheen, while the narrow nose suggests intolerance. This is a ruler who is neither good nor evil, but beyond all moral categories.

Elisabeth Charlotte, Princess Palatine, 1713

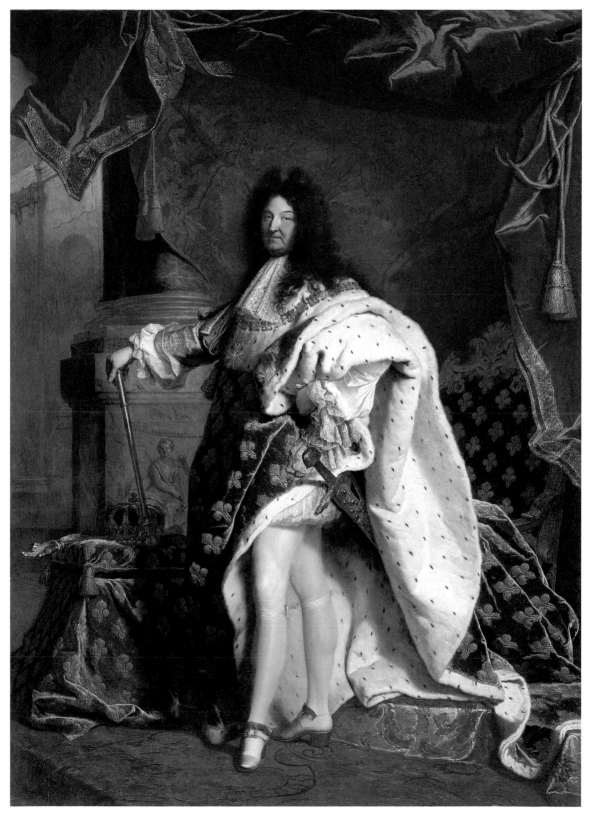

тhe glorification of the cross

Oil on copper, 48.5 x 36 cm
Frankfurt am Main, Städelsches Kunstinstitut

*** 1578 Frankfurt am Main**
† 1610 Rome

If coping with mass was a central problem of Baroque painting, it seems surprising that one of its most prominent founders worked only in small, even tiny, formats. Nevertheless the work of Elsheimer, who died at the age of 32, was largely taken up with this question. His earliest known work, *Sermon of John the Baptist* (c. 1598; Munich, Alte Pinakothek), showed some new impressions in addition to the influence of the painters of the Danube School to whom his teacher Philipp Uffenbach had introduced him. In 1598 Elsheimer had come by way of Munich to Venice, where he was much impressed by the work of Bassano and Tintoretto. These new influences already find expression in his *Burning of Troy* (c. 1600; Munich, Alte Pinakothek), probably produced while still in Venice. On the small copper plate (Elsheimer painted exclusively on copper) he created a night-time drama of great fascination, achieved through his handling of light and with a bold combination of foreground scene and background. In 1600 he moved to Rome where Bril and Rubens as well as Caravaggio and Annibale Carracci became of great importance to the gregarious and popular Elsheimer.

Between the figures of Caravaggio and the landscapes of Carracci, Elsheimer found the direction that was to make him famous, achieving a new relationship between figure and space which is absolutely natural and convincing. This becomes apparent in works such as *Myrrha* (c. 1600; Frankfurt am Main, Städelsches Kunstinstitut) and *The Flight to Egypt* (ill. p. 18). The end of his not always very easy life was tragic. Goudt, the Dutch patron, imitator, copyist and posthumous forger of Elsheimer, who had supported him financially and found customers for his engravings, had Elsheimer thrown into the debtors' prison, presumably because not enough work was forthcoming. Shortly after his release Elsheimer died.

The cross as the focal point of the "gloria del paradiso" is revered by the saints and the elect of the heavenly realm who surround the cross on banks of clouds. On the right, we recognize the patriarchs, including Moses, Abraham and King David. We also see Jonah sitting on the whale, looking up towards the cross, and St Catherine and Mary Magdalene in a sisterly embrace. In the foreground, there is a disputation between St Sebastian and Pope Gregory, St Jerome, St Ambrose and St Augustine, with the first Christian martyrs St Stephen and St Laurence. The cross, clutched by a kneeling female figure who is probably an embodiment of Faith, is surrounded by angels bearing the instruments of the Passion, above which we can make out the Evangelists and Apostles. At the head of a procession of angels streaming into the dazzling light of the background, which is flooded with an overwhelming brightness, we can see the Coronation of the Virgin.

Elsheimer's unique art is evident in the astonishing illusion of remarkable breadth and depth achieved by this small panel painting. Here, space is no longer simply a problem of continuously reduced scale, but also one of simultaneous graduation of colour and the distribution of light and darkness. This creates interlocking areas of colour and light which, though perceived by the eye, nevertheless take on the quality of a vision. This painting, originally part of a triptych, is widely regarded as Elsheimer's greatest masterpiece.

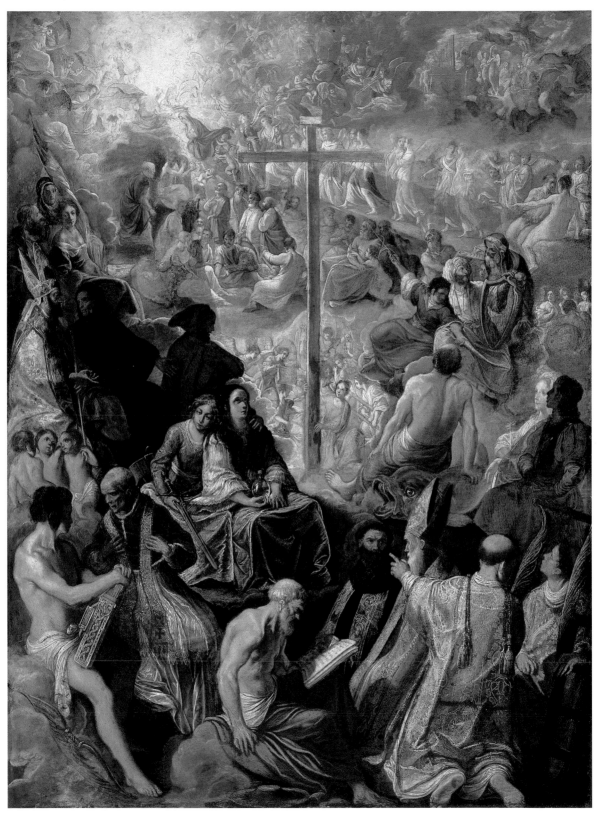

still Life

Oil on copper, 78 x 67 cm
Munich, Bayerische Staatsgemäldesammlungen, Alte Pinakothek

* c. 1566 Olmütz (Mähren)
† 1638 Frankfurt am Main

Nothing is known of Flegel's beginnings, but presumably he received his training in the Netherlands. There is evidence that he worked at least from 1594 in Frankfurt am Main, at first as an assistant to the Flemish artist Lucas van Valckenborch, whose paintings he adorned with fruit, metalware and flowers. On his way to becoming the first, purely still life painter in Germany, his work as a miniaturist was of particular importance; for example, in about 1607 he illuminated the breviary of Duke Maximilian I of Bavaria. Flegel's early still lifes – amongst which the present undated *Still Life* may be counted – therefore bear strong marks of this finely detailed art, including small decorative additions (*Fruit Still Life*, 1589; Kassel, Staatliche Kunstsammlungen). Flegel subsequently (as from 1611) arrived at a much more unified, considered composition. With one of his last pictures, the *Still Life with Candle* (1636; Cologne, Wallraf-Richartz-Museum), he succeeded in creating a work of tremendous atmospheric power and artistic simplicity.

The very Netherlandish-looking bouquet of flowers with tulips, carnations, roses and narcissi, is as superbly painted as the silver vase ornamented with golden mascarons in which it has been placed. The different qualities of silver, gold and pewter, their various degrees of brilliance, hardness and finish have been rendered in painstaking detail. The heavy pewter plates are juxtaposed with an elegant, fine-rimmed silver dish and a golden-lidded chalice bearing a fine statuette of Mars. The blade of the knife at the edge of the table, the dish of hazelnuts, the lid and edge of the brown earthenware jug – all are variations on the artist's theme. The display of foodstuffs seems less impressive at first glance, and arranged almost at random. Everything seems to be arranged by pure chance, so much so in fact that an allegorical interpretation seems unlikely. Though the composition may appear purely cumulative, it is nevertheless precisely calculated, especially in the masterly distribution of colour highlights.

Still Life with Bread and Sugar Confectionery, undated

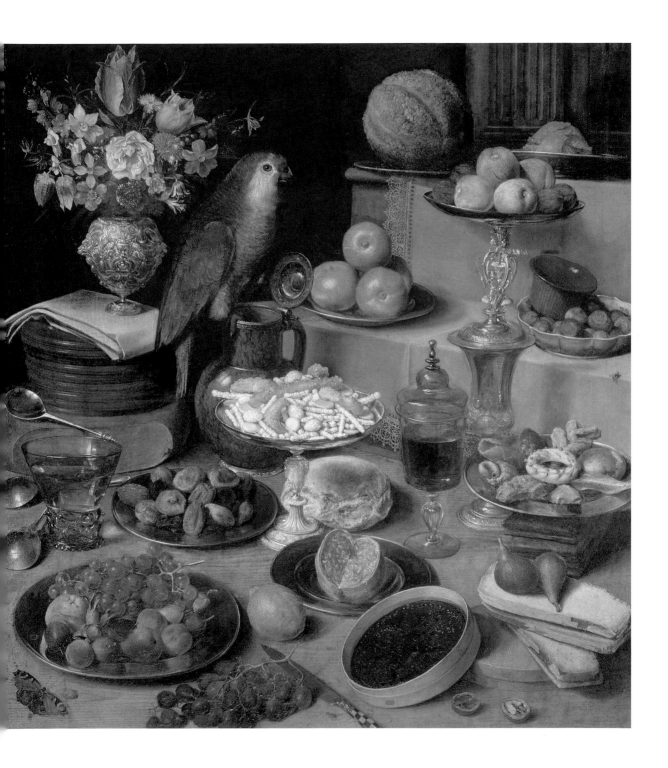

st christopher

Oil on canvas, 127 x 100 cm
Madrid, Museo del Prado

* 1591 Játiva (near Valencia)
† 1652 Naples

In Valencia Ribera was trained by Ribalta, who introduced him to his tenebrism, a technique of painting in a dark, low key, characterised by contrasting use of light and shade. On his travels to Parma, Padua and Rome, Ribera became acquainted with the works of Raphael, Correggio, Titian and Veronese. In 1616 he settled in Naples and developed a style which owed much to Caravaggio. There he became painter to the Spanish Viceroy and later to his successor, the Duke of Monterrey, who procured for him commissions from the Augustine monastery in Salamanca (*Nativity*, *Pietà*, *The Virgin with SS Antony and Augustine*, 1631–1635). He subsequently abandoned the dark and sombre style, finding new ways of treating light and using brilliant colours (12 pictures of the prophets, 1637/38, Naples, Museo Nazionale di San Martino).

His *Boy with a Clubfoot* (1642; Paris, Louvre) is typical of his more mature style, both thematically and in terms of pictorial composition. During this period of realism he had a leaning towards harrowing subjects, the crippled and malformed. Italian, Spanish and Flemish painters were engaged in his workshop, and while Ribera was of particular importance to Neapolitan art, great painters, such as Rembrandt and Velázquez, also found him an inspiration.

According to legend, the giant Ophorus carried the infant Christ across a river at night, and was pressed down below the surface of the water by the weight of the child, thereby being baptized. Thereafter he received the name Christophorus ("bearer of Christ"). In this night scene, Ribera reiterates the legend, but he adds more: he brings life to the figure of the giant, lending him an expression of incredulity and astonishment at the sight of the infant Christ. His physical power is evident in the drawing of his muscles of arms and shoulders. Paradoxically yet fittingly, Ribera has given him the flickering shadow of all-devouring ecstasy that predominates in a heightened form in his depictions of monks. It is a scene of superficial poverty without the brilliance of colour and luminosity. The miraculous experience of Christophorus is neither majestic nor historic, but is a sacred occurrence repeated daily before our very eyes.

> "Through studying the works of caravaggio, Ribera gained such a great deal that he reached the pinnacle of his art, surpassing even the most celebrated artists of his day."
>
> Antonio Palomino

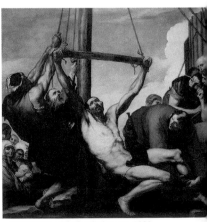

Martyrdom of St Bartholomew, 1630

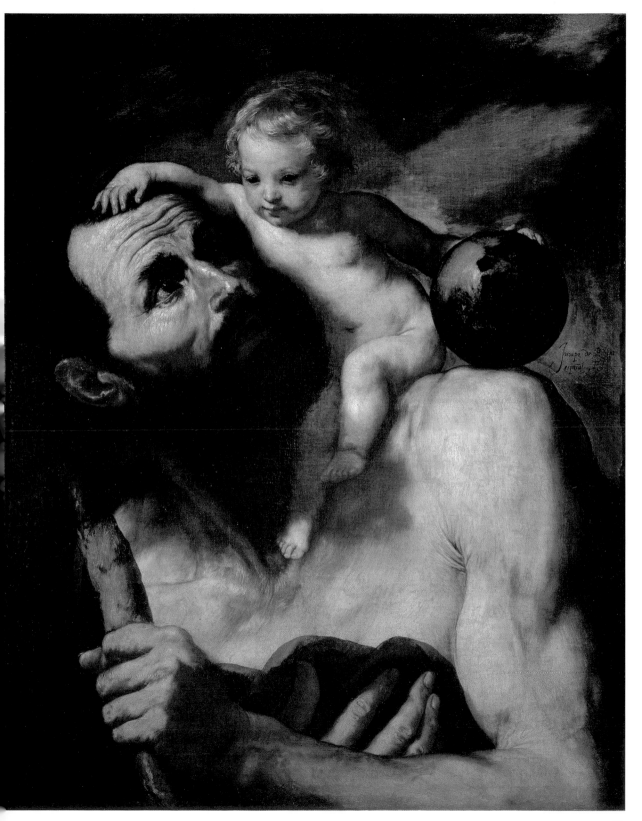

65

st margaret

Oil on canvas, 192 x 112 cm
London, National Gallery

*** 1598 Fuente de Cantos
(Estremadura); † 1664 Madrid**

Zurbarán was trained in Seville in 1616/17 by an unknown painter and settled in 1617 near his birthplace to paint a large number of religious pictures for the monasteries of Seville. His work included many pictures of saints at prayer and devotional still lifes in the spirit of the Counter-Reformation. His tenebrist style, reminiscent of Herrera the Elder, with its massively simple figures and objects, clear, sober colours and deep solemnity of feeling expressed in thickly applied paint, made him the ideal painter of the austere religion of Spain.

In Seville, where he settled in 1629, he became the leading artist. There he produced many altarpieces and decorated a number of monasteries with extensive fresco cycles. His fortunes fell with Murillo's rise. Having been appointed "pintor del rey" in 1634, he was compelled to supplement his income by acting as an art dealer only a decade later. In 1658 he moved to Madrid, where he entered the Santiago Order. Caravaggio, Velázquez, El Greco, Cotán, Dürer, Raphael, Titian – all these left traces in his work, which is nevertheless of great originality.

In the œuvre of Zurbarán, religious themes predominate, with particular emphasis on asceticism. The apocryphal legend of the life and death of Margaret of Antioch was known in the western world as early as the 7th century. Cast out by her heathen father, she was martyred in the Diocletian persecution of Christians and decapitated. In the course of the centuries, more and more legends grew up around this popular martyr. Zurbarán has portrayed her with straw hat and staff, in the costume of a Spanish shepherdess. Behind her we see the dragon which she is said to have overcome with the sign of the cross. Completely inactive, with the Bible in her left hand and a woven shepherd's bag over her arm, she gazes at the spectator with a sweetly childish face. This painting does not tell the turbulent episodes of her life, but shows a saintly woman revered in the home country of the painter.

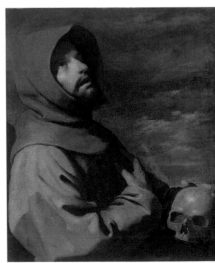

The Ecstasy of St Francis, c. 1660

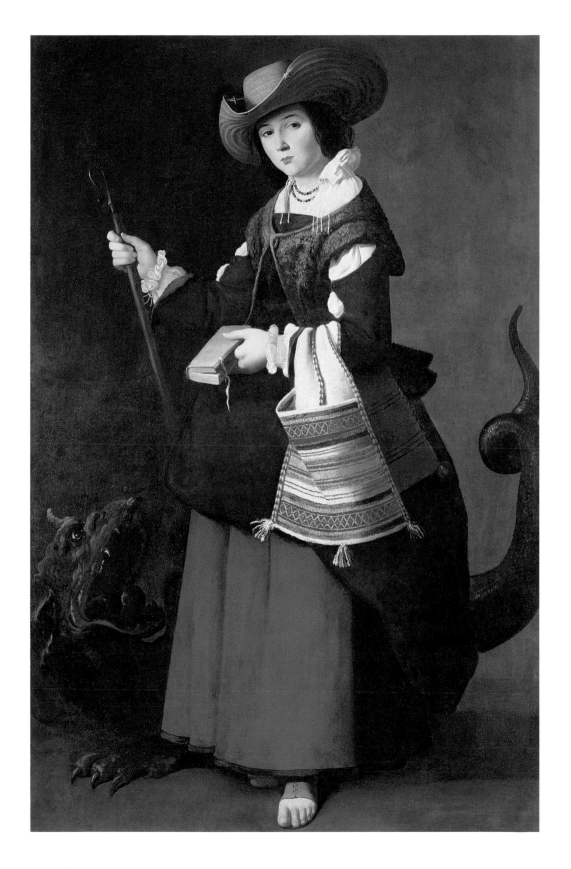

тhe Little Fruit seller

Oil on canvas, 149 x 113 cm
Munich, Bayerische Staatsgemäldesammlungen, Alte Pinakothek

* c. 1617/18 Seville
† 1682 Seville

Murillo was the youngest of fourteen children of a doctor in Seville, where he probably remained all his life, a visit to Madrid in 1642 being unsubstantiated. Orphaned at the age of ten, he was apprenticed early to a painter by the name of Castillo. He gained sudden fame with the cycle of paintings he did for the cloisters of the the Franciscan monastery in Seville (1645/46). While his earliest works show him working in a tenebrist style derived from Zurbarán and then in the style of Ribera with a preference for cool colours, he soon developed his characteristic style of soft forms and warm colours, which owed something to the works of van Dyck, Rubens and Raphael which he had studied in local collections. Today considered somewhat sentimental, his genre scenes nevertheless represent a new way of perception (*Grape and Melon Eaters*, Munich, Alte Pinakothek; *The Little Fruit Seller*). When Hegel said about Murillo's beggar children that they sat on the ground "happy and blessed like the Olympian gods", he cleared them of pathos, and so brought out the sensitisation for simple objects and feelings which would first find full expression in the 18th century. Murillo's many devotional pictures, particularly of the Madonna, reflect a piety which was sensitive and close to the people. Apart from this new approach he commanded a brilliant painterly technique, which made him the head of the Seville school. He also founded the Academy of Seville and became its president.

A little girl with the face of a Madonna, a cheerful little boy examining the earrings she holds in her hand and a basket full of grapes which is, in itself, a still life of the highest quality. Does this painting show us a life free from worry? The apparent poverty of the two figures, their unchildlike but necessary employment, suggest a sense of hopelessness and misery. And yet these children seem to exude an air of rapt serenity and contented enjoyment of life. Herein lies Murillo's Christian message: because these children do not see their poverty as a burden, and because they do not regard their existence as joyless, they are beautiful and "dignified". It is thus a painting that could adorn the walls of any ruler's palace.

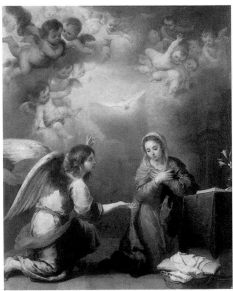

Annunciation, c. 1660–1665

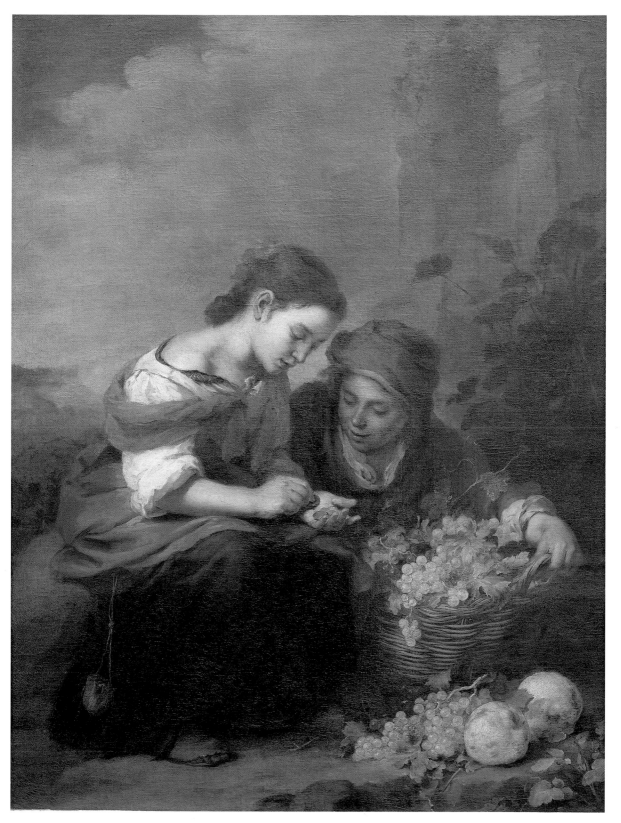

Las Meninas (The Maids of Honour)

Oil on canvas, 318 x 276 cm
Madrid, Museo del Prado

*** 1599 Seville**
† 1660 Madrid

Velázquez' father was the descendant of a noble Portuguese family, which was to become a significant factor in his career at the Spanish royal court. He studied briefly under Herrera the Elder, then was apprenticed to Francisco Pacheco whose daughter Juana he married in 1618. During that year his first dated painting was produced. In 1622/23 he travelled with his father-in-law to Madrid, to be introduced at the court. There he was appointed "pintor del Rey", but, as was the custom of the day, without a fixed income. Velázquez' estimation at court rose rapidly. After a painting competition in 1627 he was appointed gentleman usher to the King and later, in 1652, palace chamberlain. Important was his meeting with Rubens, who visited the Spanish court on a diplomatic mission in 1628. Perhaps this inspired him to visit Italy, where he met Ribera in Naples. After having been appointed painter to the royal chamber in 1643, he had another opportunity to visit Italy five years later in order to buy pictures for the royal collection. In Rome he was honoured by being made a member of the Accademia di San Luca after having exhibited one of his pictures publicly. Two years before his death he was made a knight of the Order of Santiago.

This is a composition of enormous representational impact. The Infanta Isabella stands proudly amongst her maids of honour, with a dwarf to the right. Although she is the smallest, she is clearly the central figure; one of her maids is kneeling before her, and the other leaning towards her, so that the standing Infanta, with her broad hooped skirt, becomes the fulcrum of the movement. The dwarf, about the same size as the Infanta, is so ugly that Isabella appears delicate, fragile and precious in comparison. On the left in the painting, dark and calm, the painter himself can be seen standing at his vast canvas. Above the head of the Infanta, we see the ruling couple reflected in the mirror.

The spatial structure and positioning of the figures is such that the group of Las Meninas around the Infanta appears to be standing on "our" side, opposite Philip and his wife. Not only is the "performance" for their benefit, but the attention of the painter is also concentrated on them, for he appears to be working on their portrait. Although they can only be seen in the mirror reflection, the king and queen are the actual focus of the painting towards which everything else is directed. As spectators, we realize that we are excluded from the scene, for in our place stands the ruling couple. What seems at first glance to be an "open" painting proves to be completely hermetic – a statement further intensified by the fact that the painting in front of Velázquez is completely hidden from our view.

> **"Here we have him, the true painter of reality."**
>
> **Pablo Picasso on Velázquez**

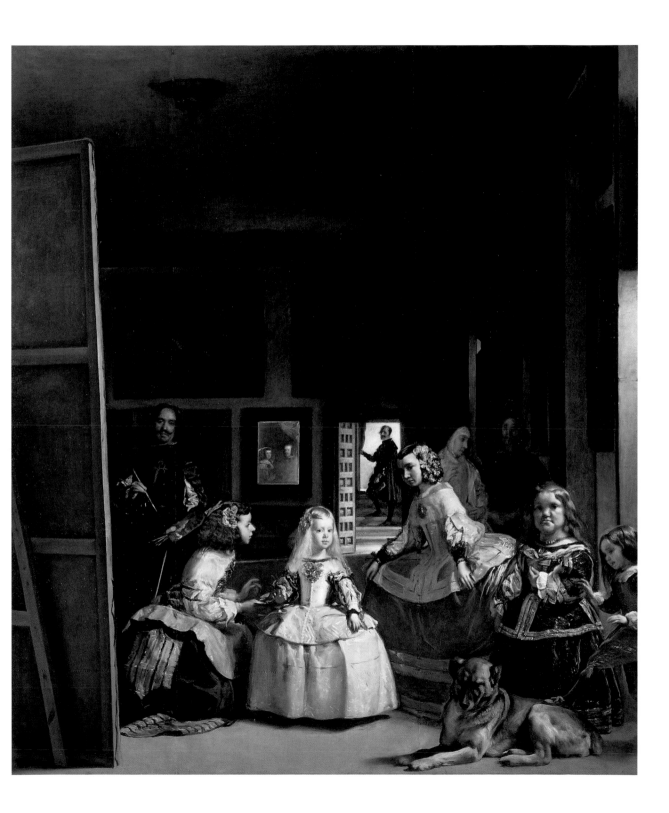

THE HOLY FAMILY

Oil on panel, 93.5 x 72 cm
Munich, Bayerische Staatsgemäldesammlungen, Alte Pinakothek

==

*** 1568 Brussels**
† 1625 Antwerp

Because of his penchant for certain themes and glowing enamel paint, Jan, the second son of Pieter Brueghel the Elder, was given the nickname "Velvet" or "Flower" Brueghel. His work, which distinguishes itself from his father's by a refined technique and miniature-like delicateness, was given direction by his grandmother, a miniaturist painter, and his teachers, including Pieter Goetkint and Gillis van Coninxloo. Brueghel spent the years 1589–1596 in Italy; he worked in Rome in 1593/94 and then in Milan in 1596 for Cardinal Federigo Borromeo. In 1597 he returned to Amsterdam and became a member of the Lukas Guild. In 1610 the Archduke of Austria, governor of the Netherlands, appointed him court painter.

Brueghel was well-to-do and respected, owning several houses in Antwerp as well as a considerable art collection. He was a friend of Rubens with whom he collaborated, executing the magnificent flower garland in Rubens' *Madonna in Floral Wreath* (c. 1620; Munich, Alte Pinakothek) while Rubens painted Adam and Eve in Brueghel's *Paradise* (c. 1620; The Hague, Mauritshuis). Besides historical scenes, paradisiacal images of animals, and genre scenes, he was above all a painter of landscape, often with staffage figures and animals in the foreground, and of flower pieces. As a specialist of "accessories" he collaborated with Frans Francken, Hans Rottenhammer and Joos de Momper.

The Holy Family leaves us in little doubt as to why the artist was known as "Velvet" Brueghel. It is a masterpiece of "fine" painting in which elements of floral still life, landscape painting and devotional painting are combined into a harmonious whole. A magnificent garland of meticulously painted flowers and fruits reflecting the diversity of nature frames the idyllic scene like a triumphal arch. It forms the letter M for Mary, who is seated as in a "beszlozzenen garten" or *hortus conclusus* dominating the middle ground with the Christ child on her knee. Beside her are the angels and the lamb, slightly behind her is Joseph and in the background is a view of a landscape with grazing deer. The figures were painted by Pieter van Avont – an excellent example of the way specific painterly tasks were delegated according to artists' specialisations within Netherlandish painting.

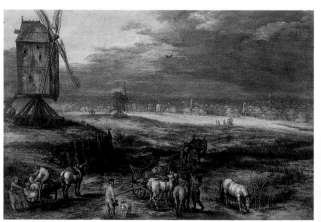

Landscape with Windmills, c. 1607

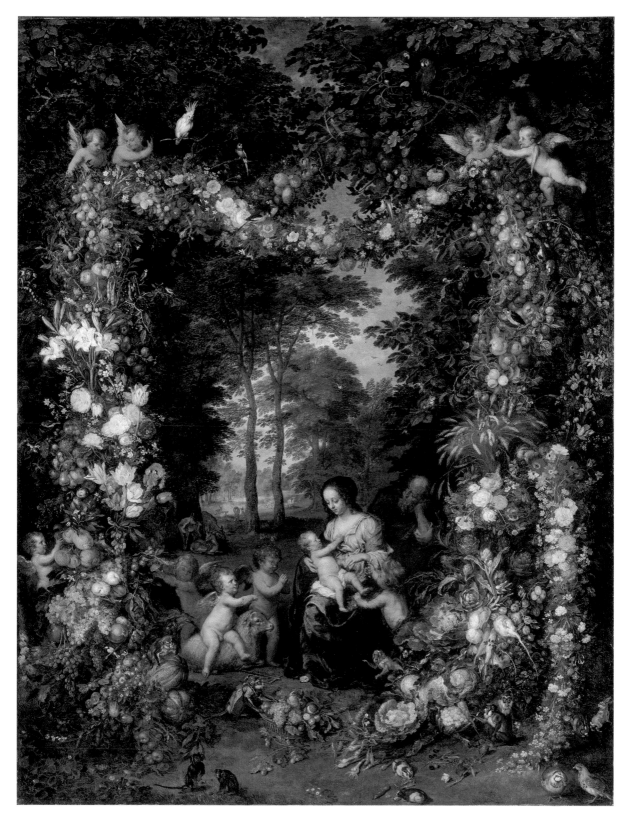

Rubens with his First wife Isabella Brant in the Honeysuckle Bower

Oil on canvas, 178 x 136.5 cm
Munich, Bayerische Staatsgemäldesammlungen, Alte Pinakothek

* 1577 Siegen
† 1640 Antwerp

Since his father was a Calvinist and had to live in exile from Antwerp, Rubens grew up in Cologne. In 1587, following his father's death, his mother returned to Antwerp, where Rubens was brought up and educated in the Catholic faith. At the age of 14 he entered the household of a Flemish princess as a page, and later studied under Tobias Verhaecht, a landscape painter, under Adam van Noort, and finally under Otho Venius. In 1598, while still working in the latter's workshop, he was accepted into the Lukas Guild as a master. In 1600 he visited Italy, and while in Venice attracted the attention of Duke Vincenzo Gonzaga, finally taking up residence at his court in Mantua. Rubens accompanied the duke on his travels to Florence and Rome, and was sent by him on a diplomatic mission to Spain in 1603. In Venice, Rome and Genoa, Rubens copied Titian, Tintoretto and Raphael, and also the works of contemporaries, including Caravaggio, the Carracci and Elsheimer. Having already executed several large commissions in Italy, he returned as a successful painter to Antwerp in 1608. In 1609 he was appointed court painter to regents Albert and Isabella, receiving an annual salary of 500 guilders, and was exempted from the guild's restrictions and taxation. He received permission to establish himself outside the regent's residence, which was in Brussels, and married Isabella Brant, daughter of the town clerk. In 1610 he built himself a large house and studio. During his Antwerp period, until 1622, he received a flood of commissions from the Church, state and nobility, employing in his large workshop many pupils and assistants who later became famous in their own sight. They included van

Dyck, Jordaens, Snyders and Cornelis de Vos. The Gobelin factory produced tapestries after his sketches, and his paintings were turned into engravings, disseminating the "Rubens style" all over Europe. Between 1623 and 1631 he travelled frequently on diplomatic missions, visiting London and Madrid, where he received peerages from both Charles I of England and Philip IV of Spain. Isabella Brant died in 1626; a year later he sold his great art collection, which included works by Raphael, Titian, Tintoretto and himself, for 100000 guilders to the Duke of Buckingham, and in 1630 he married the 16-year-old Helene Fourment, whom he immortalised in many portraits. After the death of Queen Isabella he gradually withdrew from court and bought Steen castle near Mecheln.

Rubens successfully married northern and Flemish elements of the Baroque with those of Italy. His influence on the painting of his century was enormous, as it was on sculpture and architecture. His sometimes gigantic "pictorial inventions", which do not always appeal to today's taste, were pioneering in composition, design and the art of colour, taking as subject all the major themes of painting.

This double portrait was probably executed to celebrate Rubens' marriage to Isabella Brant, the daughter of an Antwerp patrician. Rubens had returned from Italy the previous year, having achieved fame and renown at the court of Mantua. The marriage was in keeping with his social standing and this is also reflected in the painting. Rubens was familiar with such portrayals of happily married couples from Italian paintings of the 16th century. However, he heightens the significance through symbolic and emblematic references. The couple are seated in a bower of honeysuckle, a plant frequently associated with marital love and emotional constancy. Their hands are joined, indicating that the marriage ceremony has already taken place. This portrait is remarkable for its painstakingly detailed treatment of each and every object and for the accuracy with which fabrics, lace and embroidery are rendered.

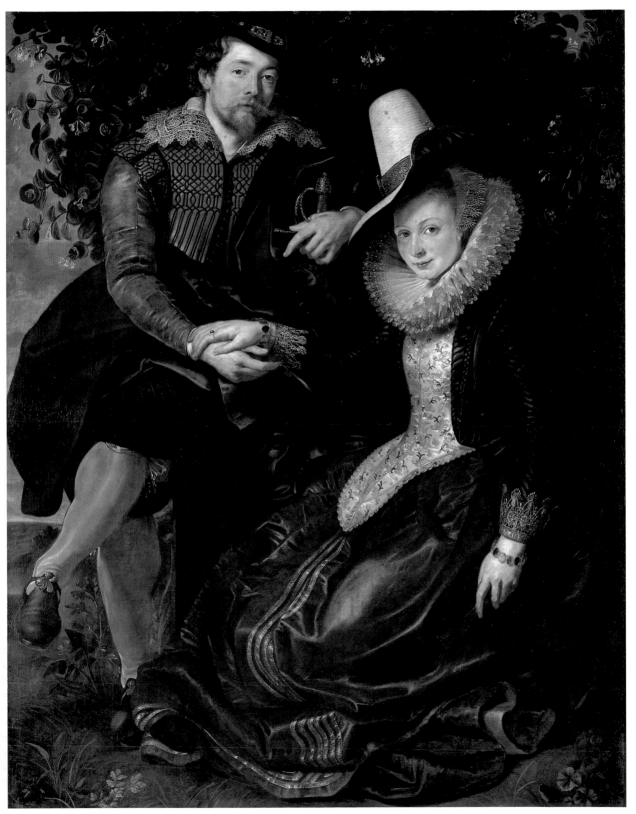

Portrait of willem van Heythuysen

Oil on canvas, 204.5 x 134.5 cm
Munich, Bayerische Staatsgemäldesammlungen, Alte Pinakothek

> **"I work to maintain my reputation. The painter must conceal the servile and painstaking labour that goes into achieving the likeness that a portrait demands."**
>
> Frans Hals

* c. 1581–1585 Antwerp
† 1666 Haarlem

Frans Hals was the son of a cloth-maker from Mecheln. He was Flemish by birth and was born in Antwerp or Mecheln. His parents moved to Haarlem, where his younger brother Dirck was born in 1591. Apart from one or two short visits to Antwerp and Amsterdam, Hals never left Haarlem. About 1600–1603 he was trained in the workshop of Karel van Mander who is most remembered for his writings on the history of art. In 1610 he became a member of the Lukas Guild, and in 1644 its head. He was highly esteemed in Haarlem, as is shown by the fact that he received altogether eight commissions for the large civic guard pictures. But Hals was often in debt as his portraits were not "elegant" enough for contemporary taste, so that he never became a fashionable painter. Also, he had to provide for ten children from his two marriages. His surviving work comprises about 300 paintings, and the majority of these are portraits and group portraits. Although also a genre painter after 1626 when he had become familiar with the Utrecht Caravaggists, these still remained portraits except that they also contained symbolic accessories or were painted in a narrative manner. Hals certainly was the foremost painter of the Dutch group portrayal. Already with his first commission, the *Banquet of the Officers of the St George Civic Guard* of 1616, he revolutionised this branch of painting which had so far been restricted to lining up several single portraits. But he never presented the scene in a theatrical fashion, as Rembrandt did with his *Night Watch*, and each of his sitters is given individual and equal attention. His last two group portraits were the *Regents* and *Regentesses of the Old Men's*

Almshouse in Haarlem (both 1664; Haarlem, Frans-Hals-Museum). In his large single or double portraits, as in the present life-size *Portrait of Willem van Heythuysen*, Flemish elements and the influence of Rubens become evident, with the background showing views and scenic staffage. His special devices used for livening up the picture are most evident in his genre portraits (*The Gypsy Girl, The Merry Drinker, Malle Babbe*, c. 1629; Berlin, Gemäldegalerie). With a spontaneous and seemingly improvised brushstroke, he produces light reflections on the faces, objects, cloth and lace, thus creating an effect of immediacy as well as vitality. Apart from his son Dirck and the imitator of his style, Judith Leyster, his pupils included the Ostade brothers; he also greatly influenced Steen and Terborch.

A wealthy merchant presents himself in noble guise. The bunch of roses, the vineleaf on the floor and the lovers in the background may well be intended as signs of mortality, recalling the labour of amassing earthly goods; perhaps the doorway draped with a curtain is the doorway of the temple of Mars, which was kept closed during times of peace in ancient Rome.

Dutch portraits tend to be full of such hidden codes which hint at the identity of the figure portrayed, and in this case they tell us that the man is a merchant who has responsibilities in times of peace and war. Neither the pose nor the symbolic attributes are meaningless signs; they are the lavish attributes of a man who presents himself as an important figure. The air of the *nouveau-riche* parvenu, to be found in so many Dutch portraits of this type, featuring showily dressed burghers, is offset by the duality of the composition in which all things of beauty are merely outward signs of dignity, full of vanity and masquerade, things of fragile and transient charm.

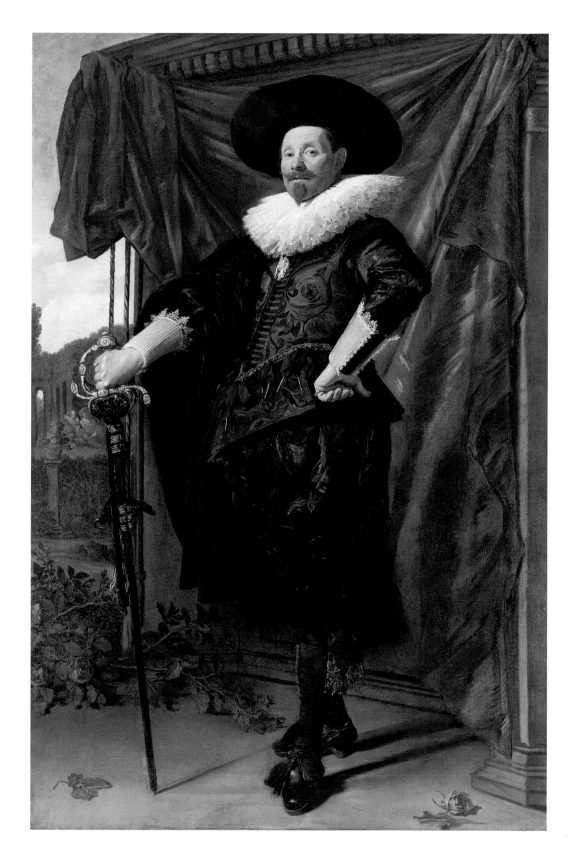

THE DUO

Oil on canvas, 106 x 82 cm
Paris, Musée National du Louvre

* c. 1588 near Deventer
† 1629 Utrecht

Terbrugghen grew up in Utrecht, where he received instruction from the late Mannerist painter Bloemaert. In 1604 he went to Italy for ten years. There he may have been in direct contact with Caravaggio, either in Rome or Naples, and also met his followers, including Orazio Gentileschi and Carlo Saraceni, whose influence became decisive.

With Dirck van Baburen and Gerrit van Honthorst he brought the chiaroscuro technique to Utrecht, where he became a member of the Lukas Guild in 1616. His religious, half-length figural works probably met with little enthusiasm, for he increasingly turned to genre painting, choosing as subject matter drinking, card-playing and musical scenes. He was the most vital and uncompromising member of the Utrecht school. The soft lighting developed by him anticipated the Delft school.

Terbrugghen's portrait of a lute player accompanied by a buxom singer who is clapping the rhythm was created a year before he died. His highly lit modelling draws the sensual and realistic appeal of his figures into the foreground of the painting. It is a "loud" painting in the sense that he makes a distinct attempt to reach the spectator with persuasively captivating painterly skills and sophisticated handling of light. A popular and consistent iconographical structure sets the theme of such paintings, which can be broken down according to the "five senses": hearing (as in this example), smell, sight, touch and taste, often painted as a series, sometimes as personification and frequently found in Dutch genre paintings.

Pictures of musicians, table rounds, banquets, raucous peasants – all are embodiments of the allegorical concepts of these "five senses". The compositional structures and formula of pathos were often adopted from existing paintings, particularly from the works of Italian artists, most notably Caravaggio.

"At his own inclination, prompted by profound but melancholic thinking, [Terbrugghen] took as his subject Nature and her cheerless imperfections, which he pursued very well, if disagreeably, in his works. So in turn he himself was pursued by ill fortune right to the grave, at the expense of his own welfare."

Joachim von Sandrart, 1675

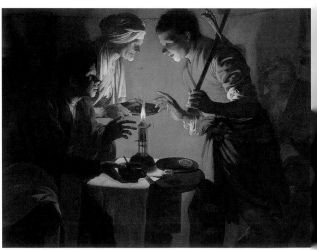

Esau Selling his Birthright, c. 1627

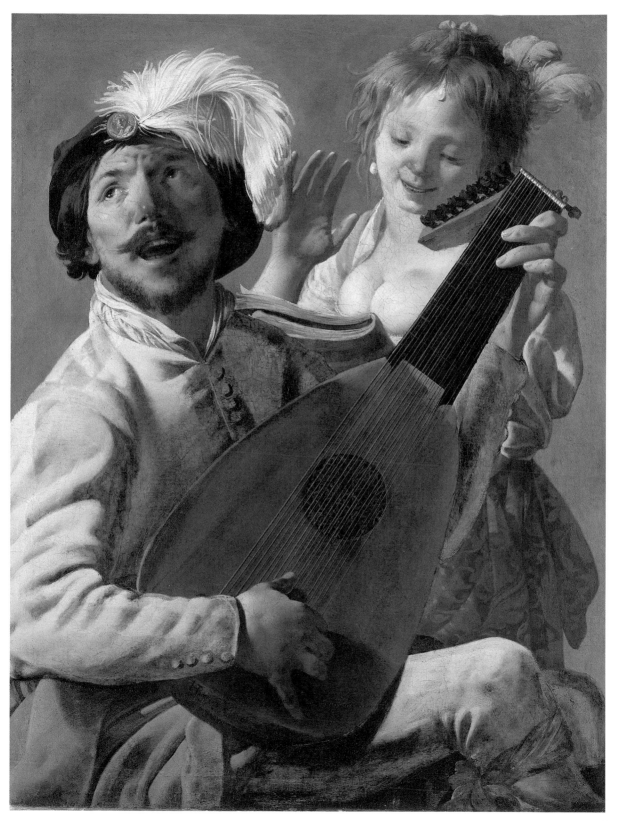

тhe satyr and the ғarmer's ғamily

Oil on canvas, 174 x 205 cm
Munich, Bayerische Staatsgemäldesammlungen, Alte Pinakothek

* 1593 Antwerp
† 1678 Antwerp

The son of a linen merchant, Jordaens was from 1607–1615 the pupil of Adam van Noort, under whom Rubens had studied briefly. He was classed as a "water painter" when joining the Lukas Guild in 1615, probably because he painted watercolours on linen which served as wall-hangings and which his father sold. In 1621 he was appointed deacon of the Guild. His reputation as designer of decorations brought in 1634 a commission from the Antwerp magistrate to collaborate on the decorations for Prince Ferdinand's visit under the supervision of Rubens, in whose workshop Jordaens had been employed previously.

Within the orbit of Rubens he not only carried out the latter's designs, such as the large canvases for the Torre de la Parada near Madrid, but adopted his style, making it his own. After Rubens' death, he became the leader of the Antwerp school, carrying out innumerable commissions for Church and court between 1640 and 1650, including 22 pictures for the salon of Queen Henrietta Maria at Greenwich, work for the Scandinavian and French courts, as well as the *Triumphs of Prince Friedrich Heinrich of Nassau* at the Huis den Bosch near The Hague, one of the few decorations of this kind to be found in Dutch palaces. Jordaens painted historical, allegorical and mythological scenes and was also a painter of religious themes and genre pictures. He was one of the great Flemish Baroque painters along with Rubens and van Dyck.

This painting is an early version of a theme Jordaens treated on numerous occasions. The strong contrasts of light and shade in the Munich canvas vividly recall Utrecht Caravaggism. Similarities with the works of Honthorst are also evident in the way the figures seem to be playing to the spectator, and in the modelling of the realistic corporeality against a dark ground. Contrasts are positively savoured, as in the juxtaposition of the ugly brown satyr and the pale-skinned young woman, the wrinkled old lady and the chubby-cheeked child. This particular genre scene is based on a fable by Aesop in which a farmer invites a satyr into his home. First, he watches the farmer blowing on his hands to warm them and then blowing on his soup to cool it. The satyr, feeling he is being made a fool of, jumps up.

Jordaens does not simply illustrate the ancient fable, but links it with the genre and history painting that may be regarded as a Netherlandish invention. The naked satyr of Greek mythology has been integrated into a Flemish household. The young woman (Catharina Jordaens) and the children are almost certainly portraits. The rustic objects and the animals are typical of a Flemish household. This lively mixture of myth and genre, past and present, fable and moral was first introduced by Rubens.

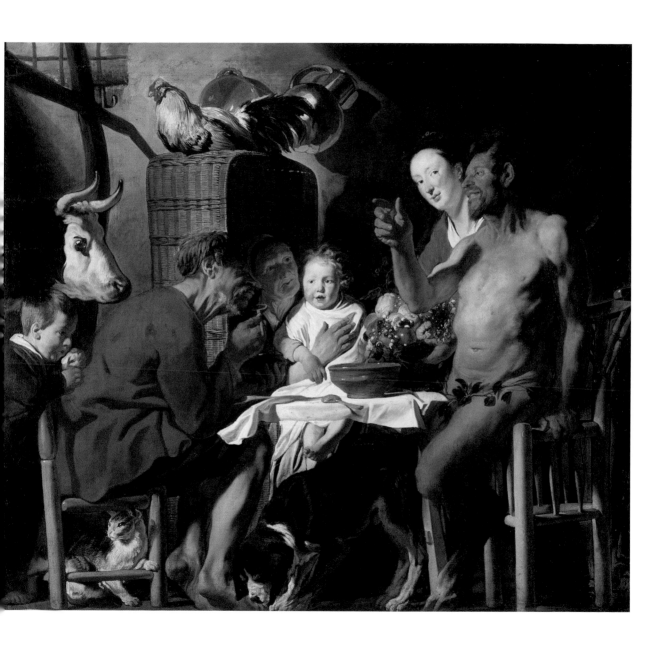

susanna and the Elders

Oil on canvas, 194 x 144 cm
Munich, Bayerische Staatsgemäldesammlungen, Alte Pinakothek

> "He copied and painted the best histories, but heads and portraits were his chief focus, with the result that he covered many sheets of paper and many canvases and steeped his brush in good venetian paints."
>
> Giovanni Paolo Bellori, 1672

*** 1599 Antwerp**
† 1641 London

Van Dyck, next to Rubens the most important Flemish painter, was the seventh child of a well-to-do silk merchant in Antwerp. After the early death of his mother he was sent at the young age of eleven to be trained by the Romanist Hendrik van Balen. In 1615 he already had his own workshop and an apprentice. In 1618 he was accepted as a full member of the Lukas Guild. From 1617 to 1620 he was the pupil and assistant of Rubens, who considered him his best pupil. They became friends, van Dyck living at Rubens' house and painting many pictures on his own after Rubens' design. Van Dyck's great talent, his untiring diligence and perhaps also Rubens' friendship combined to bring him commissions of his own very soon. Besides religious and mythological scenes he also painted some important life-like portraits, which were to become his main work. His pride and ambition made it hard for him to stand in Rubens' shadow in Antwerp. He therefore followed an invitation from the Earl of Arundel to London, where he stayed several months. From 1621 to 1627 he lived in Italy, studying the works of Giorgione and Titian. In 1627 he returned to Antwerp, where he was given a triumphal welcome. He received many commissions for churches, and became court painter to the Archduchess Isabella in 1630. In March 1632 King Charles I called him to England as court painter where he remained, apart from short visits abroad, until his end. Van Dyck became the celebrated portraitist of the English court and aristocracy, and created in this field a style typically his own. In under ten years he painted over 350 pictures, of which 37 were of the King and 35 of the Queen. His extravagant way of life – he had five servants – required a constant flow of commissions and a large studio. Often he merely made a portrait sketch, painting face and hands and leaving the rest to be completed by his assistants. He worked feverishly, weakened by thirty years' hard work and perhaps already feeling signs of his impending illness, rushing in his last years between England, Antwerp, Paris and back to England. But his great plans – frescos in the Banqueting Hall in Whitehall for the English kings, the decoration of the hunting castle of Philip IV in Madrid and a series of paintings in the Louvre for the French monarch – did not materialise, perhaps partly because his fees were exorbitant.

The painting of *Susanna and the Elders* was executed while van Dyck was in Italy, where he stayed until 1627. It clearly reflects the inspiration of Venetian painting. The deeply luminous colours especially the strong red of Susanna's mantle, are reminiscent of Titian, while the dynamic contrasts of movement are influenced by Tintoretto. What is more, the portrayal as a whole owes much to Caravaggist trend that was at its height at the time. The way Susanna moves forward out of the dark background, in luminous flesh tones and the way the heads of the two elderly men create the only light accent against the dark ground, are all reminiscent of the genre painting of Honthorst or Baburen during their Roman period. Van Dyck deliberately calculated these effects. As Susanna recoils, chaste and anxious, from the lecherous old men, she turns towards the spectato who thus becomes her protector. Contacts of this kind in which the painting involves the spectator beyond the pictorial boundaries, are often found in the work of the Caravaggisti; another typical feature is the reduction of narrative to a detail involving only a few figures in a setting that is merely hinted at.

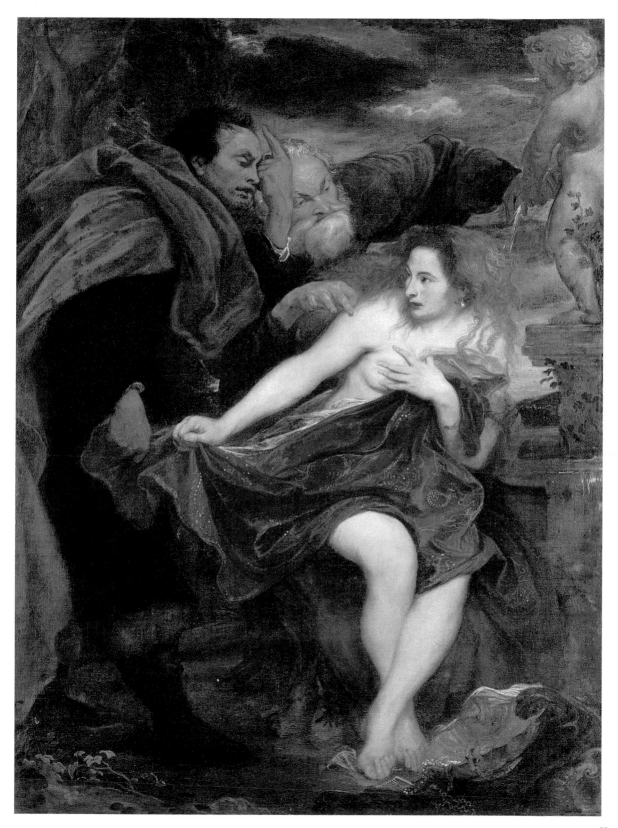

тhe Night watch

Oil on canvas, 363 x 437 cm
Amsterdam, Rijksmuseum

* 1606 Leiden
† 1669 Amsterdam

Rembrandt, the son of a miller and a baker's daughter, was originally intended to become a scholar. He went to Latin School and then enrolled at the University of Leiden. After only a year he left to become apprenticed from 1622 to 1624 to a mediocre Leiden painter, Jacob van Swanenburgh. More important for his artistic development, however, was the short period of about six months that he spent training under Pieter Lastman in Amsterdam. In 1625 he began a working association with his friend Jan Lievens in Leiden, finally moving to Amsterdam in 1631/32. He soon established himself in Amsterdam, received many commissions and opened a large workshop. In 1634 he married Saskia, a lawyer's daughter, who brought a considerable dowry into the marriage. In 1639 he bought a large house, never quite paid for, which he filled with works of art and curios. Soon his passion for collecting exceeded his finances. In 1642, the year he painted *The Night Watch*, Saskia died, and from 1649 he lived with Hendrickje Stoffels whom he could not marry without losing Saskia's legacy to their son Titus. In 1656 he went bankrupt, and his house and all possessions were put up for compulsory auction. Rembrandt spent his final years in poverty and isolation in rooms on the outskirts of Amsterdam, his powers of creation undiminished. Rembrandt was the most universal artist of his time and he influenced painting for half a century, irrespective of schools or regional style.

Probably Rembrandt's most famous and most controversial painting was given its erronious title *The Night Watch* in the early 19th century. The title referred to the subdued lighting and led art critics to seek all manner of hidden mysteries in the painting. The original title, recorded in the still extant family chronicle of Captain Banning Cocq, together with a sketch of the painting, sounds rather dry by comparison: "Sketch of the painting from the Great Hall of Cleveniers Doelen, in which the young Heer van Purmerlandt [Banning Cocq], as captain, orders his lieutenant, the Heer van Vlaerderdingen [Willem van Ruytenburch], to march the company out." It is, therefore, a "Doelen" piece or group portrait in which the captain can be seen in the foreground wearing black and the lieutenant wearing yellow. What sets Rembrandt's group portrait apart from other comparable paintings is his use of chiaroscuro as a dramatic device. Interpretations seeking a plausible action fail to take into account that the scenery is made up more or less of individual "types". For example, the horseman with helmet and lance turns up again as *Alexander The Great* (1655; Glasgow, Art Gallery) and we can also find the *Man with the Golden Helmet* (Berlin, Gemäldegalerie; recently no longer attributed to Rembrandt) in the *Night Watch*. Indeed, the painting includes the entire repertoire of portrait poses and gestures from Rembrandt's store of figures. There is inevitably a sense of celebration in the portrayal of individuals in a Dutch group painting. Yet whereas Frans Hals, for example, draws together his individual participants around a banquet scene, Rembrandt breaks up the group, so that individual characters and participants become absorbed in their own actions, each standing alone.

> **"His painting knew no outlines or delineations and used wild, unconnected brush-strokes and brush-slashes, as well as strong darks, but without going as far as pure black."**
>
> Filippo Baldinucci, 1681

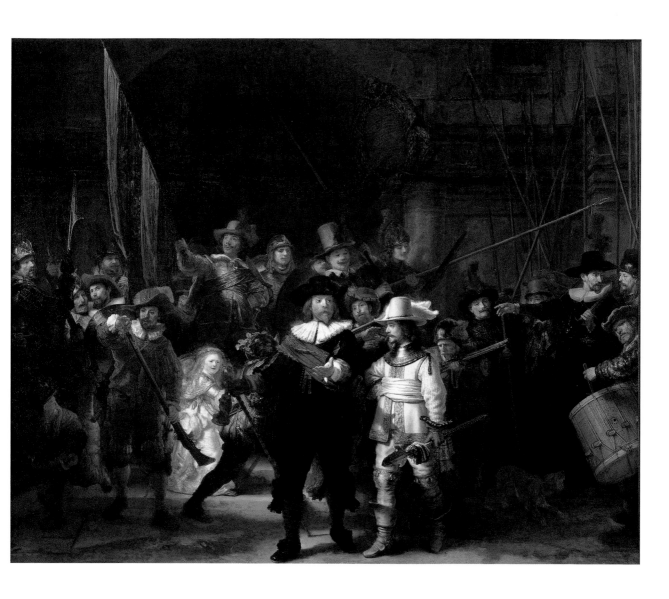

The Lovesick woman

Oil on canvas, 61 x 52.1 cm
Munich, Bayerische Staatsgemäldesammlungen, Alte Pinakothek

* 1626 Leiden
† 1679 Leiden

Steen and his teacher Ostade were the two most popular and versatile of the Dutch genre painters. Steen was the son of a Leiden brewer and led an unsettled life, often moving home, but he cannot have been an undisciplined drunkard, as has often been suggested, because he produced around 800 paintings. In Leiden he was introduced to the very detailed style of painting which was to become important in his later career. He enrolled briefly at the university in 1646, probably to avoid military service. In 1648 he was one of the founding members of the guild. He probably received his training in Utrecht and was employed in the workshops of Ostade and van Goyen. In 1649 he married a daughter of van Goyen in The Hague, where he remained until 1654. He then took over a brewery in Delft, which soon failed, and then moved to Warmond near Leiden. From 1661 to 1670 he was in Haarlem, and finally settled for the last ten years of his life again in Leiden, where he obtained a licence to operate a tavern.

In his portrayal of merry or riotous drinking scenes, weddings, fairs and other themes drawn from popular life, he proved himself a most acute observer of this particular milieu, which his life and occupation had given him ample opportunity to study. But he was also at home with the depiction of refined society and modish interiors. His style was never fixed, tending sometimes towards Ostade and Brouwer, then again towards de Hooch, Terborch or Vermeer. He treated human follies and weaknesses with humour and wit, revealing the hidden moral and "truth" as Molière did in his comedies.

Amongst the genre scenes that brought Steen popularity and fame, there are almost twenty showing a doctor's visit to a bourgeois home. As theatrical as any *Commedia dell'arte* play, they present scenes full of misunderstandings, secrets, assumptions and indiscretions. The "illnesses" of the patients are generally unforeseen pregnancy or lovesickness. The bed with the painting of lovers hanging over it, and the statue of Amor on the draughtscreen of the door, immediately indicate to the spectator what is going on. The basin of coals in the foreground with the burning thread – quack doctors diagnosed pregnancy by "reading" the smoke – and the maid with her suitor at the door are further typical features of this genre. The patient, whose pulse the doctor is counting, has a note in her hand on which the following words are written: "Daar baat gen/medesyn/want het is/minepeyn" ("No medicine can cure the pain of love").

Though hardly a profound insight, these words constitute a moral of the kind that is almost invariably to be found behind these types of Dutch paintings. For all the autonomy of the subject matter, a painting without such a "deeper" meaning would have been inconceivable at the time, and indeed did not actually emerge until the 19th century.

> "In the case of the Netherlandish artists, comedy alleviates the bad in the situation, and it is immediately clear to us that the characters can also be other than as they stand before us at this moment. Such cheerfulness and comedy belong to the inestimable value of these paintings."
>
> **Georg Wilhelm Friedrich Hegel**

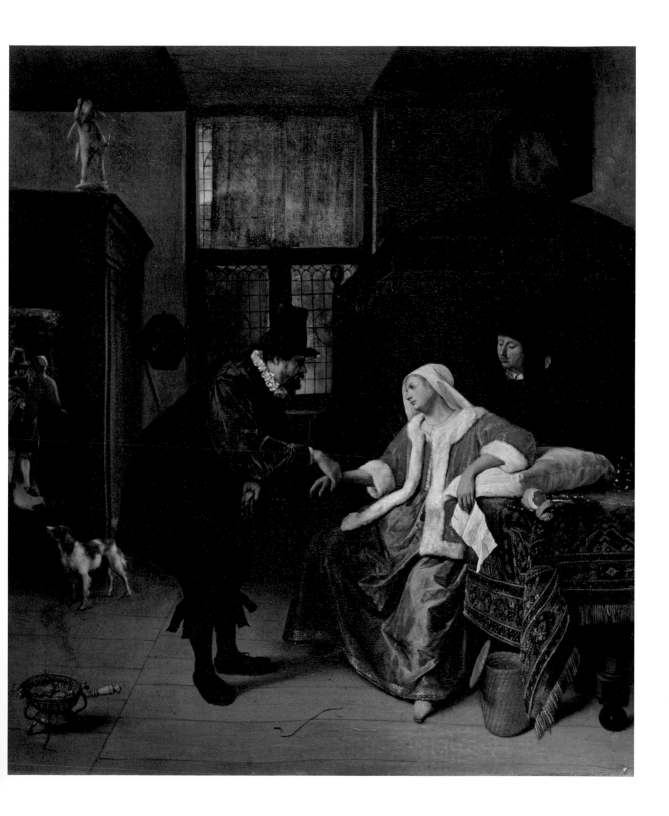

The Card-Players

Oil on canvas, 67 x 77 cm
Paris, Musée National du Louvre

*** 1629 Rotterdam**
† after 1684 Amsterdam

De Hooch's career as a painter developed very slowly. The son of a bricklayer, he received his early training under Nicolaes Berchem in Haarlem. Around 1650 he worked as painter and valet de chambre for a cloth merchant and art collector in Rotterdam, whom he had to accompany on his travels to Leiden, The Hague and Delft. After his marriage in Delft he was accepted as a member of the Lukas Guild in 1655 although not actually a citizen of the town. In about 1667 he moved to Amsterdam, where he remained to the end of his life. De Hooch's most important creative years were those in Delft. Under the influence of Vermeer and the Rembrandt student Carel Fabritius, he painted genre scenes which depict the idyll of Dutch domestic life. The private everyday life of the bourgeoisie in all its ordered tranquility, a world whose calm is never shattered by any sensational event, is the subject of his works. De Hooch opens a window on narrow alleyways, small gardens and courtyards, and gives us a glimpse into the antechambers and living-rooms of the Dutch citizens. Like Jan Vermeer, de Hooch specialized in the portrayal of interiors. A gentle light radiates through the scenes, and the figures and objects seem to pause as if in a still life. Typical for de Hooch, whose colours are warmer and softer than Vermeer's, are perspectival rooms and vistas through open doors. In his Amsterdam period, where he liked to move in elegant society, his often plain and simple interiors were replaced by grand rooms with marble mantelpieces and pilasters. His rendering became hard and over-meticulous, his coloration cold and dry.

The Card-Players belongs to the period between 1654 and 1665, when de Hooch was living in Delft. Although a certain tendency towards sumptuous interiors and elegant society is already evident here, the compositional organization is charming, and the architecture of the room with its checkerboard tiles heightening the sense of depth and perspective, is rendered with painstaking precision.

When de Hooch moved to Amsterdam in 1667, where he moved in high circles, his interiors became increasingly elegant, and his simple "households" were gradually replaced by palatial interiors. At the same time, the portrayal began to lose its precision and the vitality of the Dutch genre painting began to fade. His paintings also began to lose the strong colour values.

Courtyard of a House in Delft, 1658

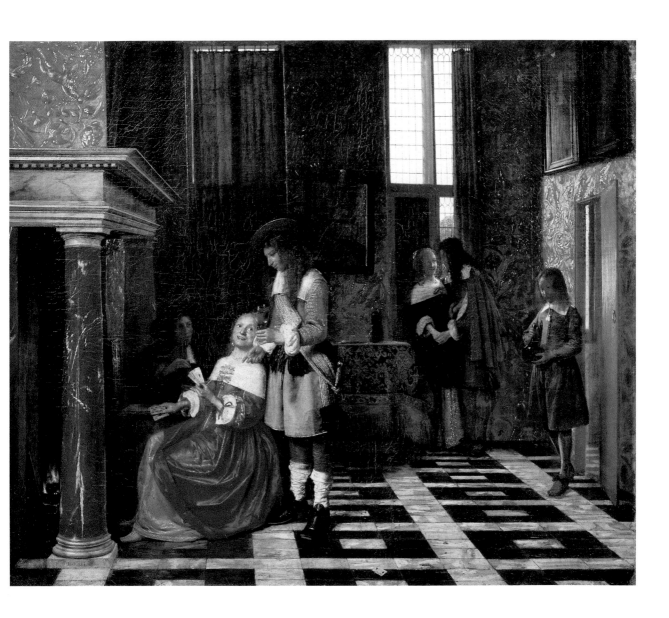

Allegory of Painting (The Artist's studio)

Oil on canvas, 120 x 100 cm
Vienna, Kunsthistorisches Museum

* 1632 Delft
† 1675 Delft

Although Vermeer was one of the greatest of Dutch genre painters, with Frans Hals and Rembrandt, and his work is unique in the history of art, very little is known about his life. He was the son of a weaver in silk and satin, who later became an art dealer and inn-keeper. Vermeer was probably a pupil of Carel Fabritius. In 1653 he married Catharina Bolens, whom he often portrayed in his pictures, and became a member of the Delft Lukas Guild. He worked slowly and therefore his output was small, and insufficient to keep a large family, although he achieved fairly high prices. Vermeer tried to supplement his income by acting as an art dealer, but this also failed. Only one of his 36 surviving paintings is dated (*The Procuress*, 1656, Dresden, Gemäldegalerie). *Diana and her Companions* (The Hague, Mauritshuis) and *Christ in the House of Martha and Mary* (Edinburgh, National Gallery) probably date from about 1655, a period when he explored Italian art and came to terms with the Utrecht Caravaggists. These were followed by genre scenes, conversation pieces, in which detail and gestures are still somewhat over-emphasised. The pictures with which Vermeer's name is now mostly associated were painted shortly before and after 1660, including *Girl Reading a Letter at an Open Window*, *The Kitchen Maid*, *Woman Holding a Balance* and *The Artist's Studio* or *Allegory of Painting*. In these intimate scenes, light itself seems to have become the subject of the picture; a moment of stillness captured on canvas. Vermeer stands apart from his contemporary genre painters through his superb draughtsmanship and skill in perspective, his colour harmonies, in which cool blue and a bril-

liant yellow predominate, and his incomparable ability in setting enamel-like highlights which impart a glow to surfaces. In his late work his treatment of light lost some of its poetry, his drawing became less fluid, and the interiors less simple. On his death his pictures were auctioned off and he was forgotten, and it was not until towards the end of the 19th century that his true significance was recognised.

The studio painting is a frequent feature of Dutch painting. Rembrandt painted himself at his easel, as did Dou, Ostade and many others after him. What is unusual about Vermeer's painting, however, is the fact that he turns a self-portrait into a complex allegory. Scholars and art historians have long debated the "correct" interpretation of this allegory, a fact which, in itself, merely underlines the complexity of the painting. The interior is full of artistic paraphernalia, and on the wall hangs a map of the free Netherlandish provinces. The painter is elegantly dressed, and working in an equally elegant room. He may well have been citing Leonardo da Vinci's treatise in which he says of painting: "… the artist sits in great comfort before his work, well dressed, and stirs the light paintbrush with graceful colours. He is dressed in apparel as he likes it." Could this be a reference to the superiority of painting over architecture and sculpture?

The artist is in the process of painting the laurel wreath worn by the model; she also has a trumpet and a book in her hands, identifying her as Fama, the allegorical embodiment of fame. This studio scene, almost like a genre painting, thus becomes an allegory of "the fame of painting" in the Netherlands. This corresponds to a generally widespread Dutch possibility of incorporating "truths" or general moral statements in what appears to be a genre painting. An unusual feature in this painting, however, is Vermeer's handling of light, unparalleled in the art of the 17th century and rediscovered two hundred years later by the Impressionists. The light falls through an invisible window onto the model, whom the painter has positioned in the most brightly lit spot. In this way, natural light becomes glorifying light – as befits an allegory.

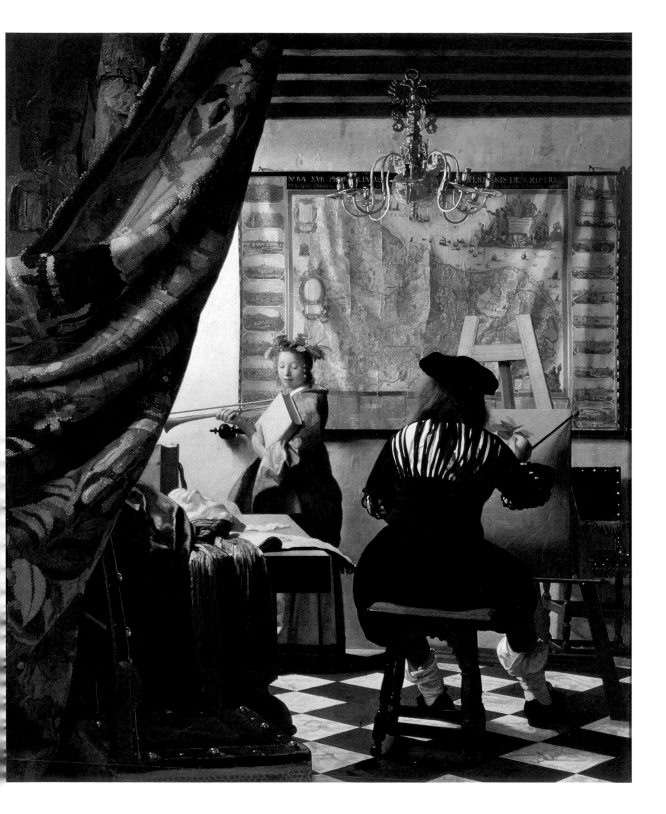

тhe cannon shot

Oil on canvas, 78.5 x 67 cm
Amsterdam, Rijksmuseum

* 1633 Leiden
† 1707 London

With his father, also a marine painter, Willem came to Amsterdam in 1636. Here his brother Adriaen was born, who became a landscape and animal painter. Willem received early instruction from his father, then was apprenticed to Simon de Vlieger, who specialised in seascapes. In 1652 he became an independent master in Amsterdam, and in 1672 King Charles II called him to England, where he was appointed court painter.

Together with Jan van Capelle he introduced a new type of marine painting, giving his ships individuality as in a portrait and presenting seafaring as a dramatic event. His sea-battles and ships at sea, usually in calm or only slightly choppy waters, are notable for their precision of detail and fine colour and for the light effects which skilfully convey mood and atmosphere.

Although he also executed history paintings in the form of sea battles, his marine pieces are differently structured. Ships of all kinds are lying at anchor and, as such, are remarkable subject matter. The painter certainly knew his subject, and he would hardly have found any buyers for his works if the details of his ships, from hull to sails, had not been realistic. Yet the manner in which he arranges his meticulously rendered vessels is reminiscent of a still life composition. Here, a ship is firing a salute.

The acoustic effect is rendered visibly as a cloud of smoke and steam, as an atmospheric drama, ringing out on a sea that looks like the resonating body of a musical instrument. The French poet Paul Claudel described the painting as follows: "It is as though, at this sig-nal, at this sudden burst of sound in a cloud of smoke, nature itself had paused for a moment: fire! It is as though the sea were listening attentively, and the spectator too. This is one of those paintings you can almost hear rather than see."

> "нolland's flat horizons have little to offer. тhe air is always hazy, which makes all the contours blurred and indistinct. ... тhe shades of brightness and the gradations of colour are astonishing ... a delight to the eye."
>
> **Hypolite Taine**

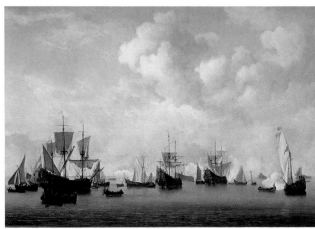

The Dutch Fleet in the Goeree Straits (Guinea), 1664

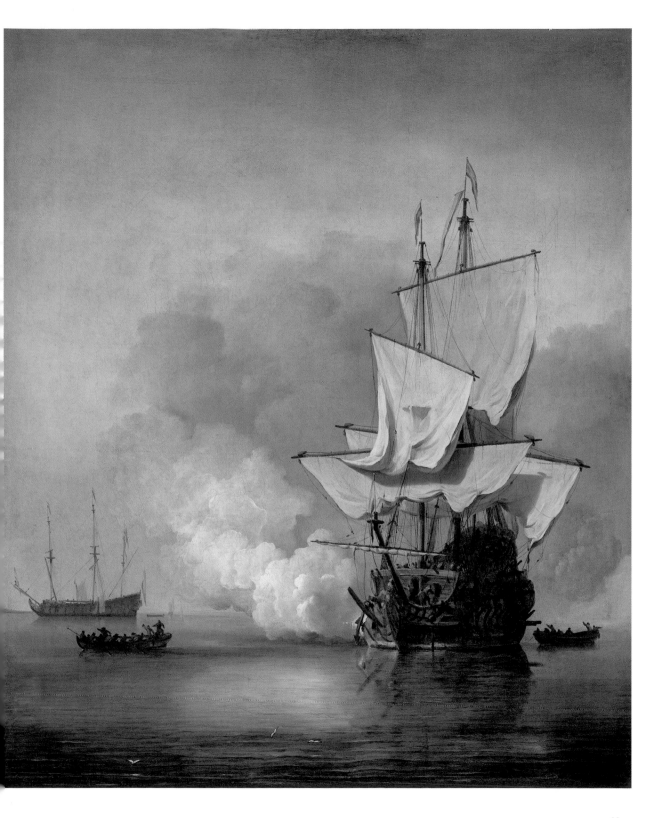

still Life

Oil on canvas, 105 x 87.5 cm
St Petersburg, Hermitage

*** 1619 Rotterdam**
† 1693 Amsterdam

Kalf was considered by his contemporaries as having exceptional intellectual gifts and being well-versed in the arts. He probably received his training from Frans Ryckhals and Hendrick Pot. In 1640 he went to Paris for six years, where he was a success with his pictures of kitchens and interiors of peasant dwellings. With these pictures of untidy storage rooms and passages cluttered with tools and female servants, he created a genre that Chardin was to revive in the 18th century. But he was first and foremost a still life painter, initially depicting simply laid breakfast tables with the remains of the repast, glasses and pewter or silver vessels, which were reminiscent of the "monochrome banquets" of the Haarlem painters Pieter Claesz. and Willem Claesz. Heda. In compliance with the demands of the well-to-do Dutch merchant class, Kalf later produced luxurious still lifes with rich table covers, Venetian glass, Chinese porcelain and silver bowls containing tempting fruit. These are never gaudy, as can be the case with Flemish pieces, and they captivate by their suggestion of texture. Brilliant colours and the sensitive use of light effects suggest Rembrandt's influence. Most of these pictures date from the Amsterdam period between 1646 and 1663. From then on Kalf seems to have given up painting in favour of art dealing.

Kalf's magnificent still lifes vary little in their structure, and most of them feature similar objects. A damask cloth or tapestry is draped upon a table on which there is sumptuous tableware, with gold and silver vessels, many of which have actually been identified as the work of specific goldsmiths such as Jan Lutmas. There is almost always a Chinese porcelain bowl, often tilted so that the beautiful fruits tumble out of it.

Nevertheless, it would be wrong to speak of "movement" in the still lifes of Kalf. The objects in his paintings possess a fragile equilibrium, and any suggestion of dynamic movement is reminiscent of a Flemish still life with its narrative component. However, in these still lifes, the painting is reduced to its contents alone and to the portrayal of the objects' beauty, captured at a single moment in time. They are brought to life by a seeming paradox. The objects are arranged almost coincidentally, in the manner of a vanitas painting: a half-peeled lemon, a loaf from which a piece has already been broken. At the same time, they are skilfully arranged, and it is this ordered coincidence that adds to their aesthetic appeal. The painterly technique recalls the work of Vermeer, another artist who portrays the appearance of light on the surfaces of objects in glittering points of luminosity and grainy precipitation.

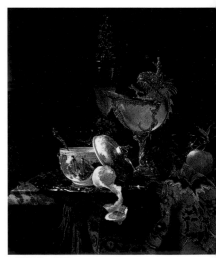

Still Life, 1662

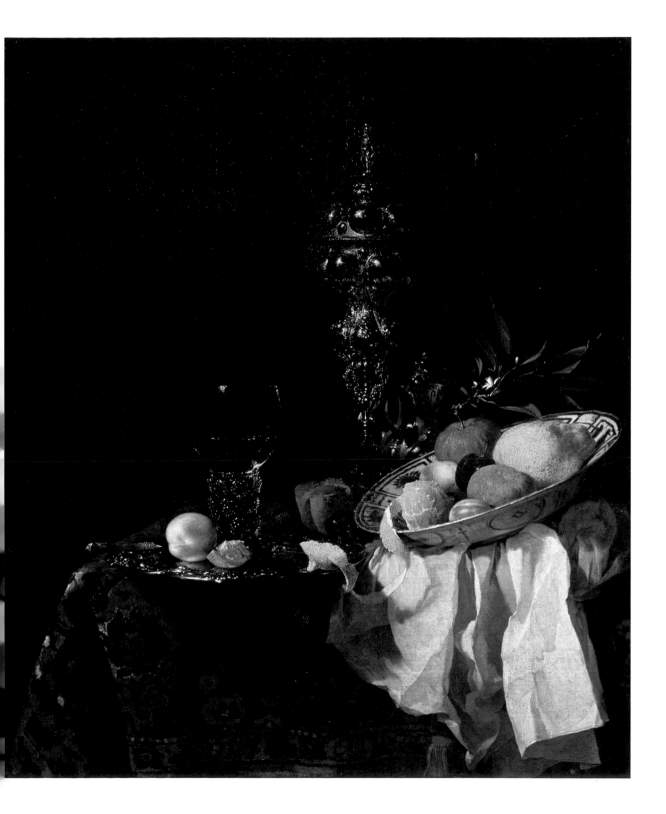

To stay informed about upcoming TASCHEN titles, please request our magazine at www.taschen.com/magazine or write to TASCHEN America, 6671 Sunset Boulevard, Suite 1508, USA-Los Angeles, CA 90 028, contact-us@taschen.com, Fax: +1–323–463.4442. We will be happy to send you a free copy of our magazine which is filled with information about all of our books.

© 2006 TASCHEN GmbH

Hohenzollernring 53, D–50672 Köln

www.taschen.com

Project coordination: Juliane Steinbrecher, Cologne
Editorial coordination: Daniela Kumor, Cologne
Translation: Ishbel Flett, Frankfurt am Main
Design: Sense/Net, Andy Disl and Birgit Reber, Cologne; Tanja da Silva, Cologne
Production: Martina Ciborowius, Cologne

Printed in Germany
ISBN 10: 3-8228-5202-X
ISBN 13: 978-3-8228-5302-3

Additional illustrations:

p. 32: Annibale Carracci, *The Bean Eater,* c. 1580–1590, Oil on canvas, 57 x 68 cm, Rome, Galleria Colonna

p. 34: Guido Reni, *David,* 1605, Oil on canvas, 222 x 147 cm, Florence, Galleria degli Uffizi

p. 36: Francesco Albani, *The Rape of Europa,* c. 1639, Oil on canvas 76.3 x 97 cm, Florence, Galleria degli Uffizi

p. 38: Guercino, *Christ and the Samaritan Woman,* c. 1640/41, Oil on canvas, 116 x 156 cm, Madrid, Museo Thyssen-Bornemisza

p. 40: Luca Giordano, *The Triumph of Galatea,* c. 1682, Oil on canvas, 51 x 66 cm, Florence, Galleria degli Uffizi

p. 44: Mattia Preti, *The Concert,* 1630–1640, Oil on canvas, 107 x 145 cm, Madrid, Museo Thyssen-Bornemisza

p. 46: Simon Vouet, *The Rape of Europa,* c. 1640, Oil on canvas, 179 x 141.5 cm, Madrid, Museo Thyssen-Bornemisza

p. 48: Georges de La Tour, *The Card-Sharp with the Ace of Diamonds,* c. 1620–1640, Oil on canvas, 106 x 146 cm, Paris, Musée National du Louvre

p. 50: Valentin de Boulogne, *David with the Head of Goliath and Two Soldiers,* c. 1620–1622, Oil on canvas, 99 x 134 cm, Madrid, Museo Thyssen-Bornemisza

p. 52: Nicolas Poussin, *Moses Trampling on Pharoah's Crown,* 1645, Oil on canvas, 99 x 142.2 cm, Woburn Abbey, Collection of the Duke of Bedford

p. 56: Charles Le Brun, *Chancellor Séguier at the Entry of Louis XIV into Paris in 1660,* 1660, Oil on canvas, 29.5 x 35.7 cm, Paris, Musée National du Louvre

p. 58: copy after: Hyacinthe Rigaud, *Elisabeth Charlotte, Princess Palatine,* 1713, Oil on canvas, Munich, Bayerische Staatsgemäldesammlungen, Alte Pinakothek

p. 62: Georg Flegel, *Still Life with Bread and Sugar Confectionery,* undated, Oil on panel, 21.5 x 17 cm, Frankfurt am Main, Städelsches Kunstinstitut und Städtische Galerie

p. 64: Jusepe de Ribera, *Martyrdom of St Bartholomew,* 1630, Oil on canvas, 234 x 234 cm, Madrid, Museo del Prado

p. 66: Francisco de Zurbarán, *The Ecstasy of St Francis,* c. 1660, Oil on canvas, 65 x 53 cm, Munich, Bayerische Staatsgemäldesammlungen, Alte Pinakothek

p. 68: Bartolome Esteban Murillo, *Annunciation,* c. 1660–1665, Oil on canvas, 125 x 103 cm, Madrid, Museo del Prado

p. 72: Jan Brueghel the Elder, *Landscape with Windmills,* c. 1607, Oil on canvas, 34 x 50 cm, Madrid, Museo del Prado

p. 78: Hendrick Terbrugghen, *Esau Selling his Birthright,* c. 1627, Oil on canvas, 106.7 x 138.8 cm, Madrid, Museo Thyssen-Bornemisza

p. 88: Pieter de Hooch, *Courtyard of a House in Delft,* 1658, Oil on canvas, 73.5 x 60 cm, London, National Gallery

p. 92: Willem van de Velde the Younger, *The Dutch Fleet in the Goeree Straits (Guinea),* 1664, Oil on canvas, 96.5 x 97.8 cm, Madrid, Museo Thyssen-Bornemisza

p. 94: Willem Kalf, *Still Life,* 1662, Oil on canvas, 79.4 x 67.3 cm, Madrid, Museo Thyssen-Bornemisza

Page 1
PETER PAUL RUBENS

Venus and Cupid
c. 1615, Oil on canvas, 137 x 111 cm
Madrid, Museo Thyssen-Bornemisza

Page 2
CARAVAGGIO

The Young Bacchus
c. 1591–1593, Oil on canvas, 66 x 53 cm
Rome, Galleria Borghese

Page 4
ANNIBALE CARRACCI

The Jealous Cyclops Polyphemus Hurls a Rock at Acis, Galatea's Lover
c. 1595–1605, Fresco
Rome, Palazzo Farnese